IMAGES
of America

A VIEW FROM
CHICAGO'S
CITY HALL
MID-CENTURY TO MILLENNIUM

A View from Chicago's City Hall

Mid-century to Millennium

Melvin G. Holli and Paul M. Green

Copyright © 1999 by Melvin G. Holli and Paul M. Green
ISBN 978-0-7385-6373-2

Published by Arcadia Publishing
Charleston SC, Chicago IL, Portsmouth NH, San Francisco CA

Printed in the United States of America

Library of Congress Catalog Card Number: 2008937383

For all general information contact Arcadia Publishing at:
Telephone 843-853-2070
Fax 843-853-0044
E-mail sales@arcadiapublishing.com
For customer service and orders:
Toll-Free 1-888-313-2665

Visit us on the Internet at www.arcadiapublishing.com

*For Susan, Chris, and Steve,
and Bobby and Sarah*

Contents

Acknowledgments		6
Introduction		7
1.	Campaigning for Mayor of Chicago	9
2.	Administration, Building, and Economic Development	63
3.	Ethnic and Racial Diversity	89
4.	Rolling out the Red Carpet	103
5.	Daley to Daley	119

ACKNOWLEDGMENTS

We would like to acknowledge the assistance of the University of Illinois at Chicago Humanities Institute Grants-in-Aid, Kathy Murphy, Institute for Public Policy and Administration at Governors State University, the City Club of Chicago, the *Chicago Sun Times*, City of Chicago Graphics and Reproduction Center, the Mayor's Press Office, the Mayor's Office of Special Events, and Rosalie Clark. We would also like to thank Monroe Anderson, Edward Kelly, Edward Marciniak, Dick Simpson, and Mayors Jane Byrne, Harold Washington, Eugene Sawyer, and Richard M. Daley for their interviews and willingness to share their thoughts and photos with us.

INTRODUCTION

This book was conceived as an effort to provide a visual road map of Chicago as viewed from the mayor's office from mid-century to the millennium. Fortunately, most of the important and especially emblematic images were caught by camera. We feel privileged to put them on display in this book.

The opening chapter deals with campaigning and politics, and pays homage to the old truism that Chicago politics are not for the timid. As Mr. Dooley, the fictional chronicler of Chicago's most over-represented political group, the Irish-Americans, observed: "politics ain't beanbag." Indeed, some would say it is a "blood sport." After Richard J. Daley's death in 1976, the late 1970s saw a stormy interregnum of racial, ethnic, and gender squabbling. It marked the city's election of its first non-Irish mayor since 1931 (Michael Bilandic, 1977); its first female mayor (Jane Byrne, 1979); and its first black mayor (Harold Washington, 1983).

After this explosive decade, which prompted the *Wall Street Journal* to tag Chicago as "Beirut on the lake," politics suddenly calmed down and returned to "equilibrium" with the 1989 election of Chicago's second Daley, Richard M. Demographic shifts also contributed to the cooling political atmosphere when it became apparent in the 1990s that Black migration from the South to the North had ended. In 1975, the city's population had stabilized with nearly equal numbers of whites and blacks (38 percent); Latinos made up about 20 percent, with Asians and some rekindled Eastern European immigrants filling out most of the rest of the city. The coming of multi-ethnic politics, along with leaders both black and white who saw the whole city as their "core" constituency, also helped to calm the explosive ethnic and racial battling of the 1980s. The closing decade of this century has been characterized by a much calmer political mood and one of more inter-ethnic and racial cooperation.

Chicago's most successful mayors in the 20th century have found in the "builder" tradition a winning political formula. Most multi-termed city hall officeholders antedating to William "Big Bill the Builder" Thompson (who left office in 1931) have found that building and development are programs that satisfy capital, labor, and taxpayers. Business and the banks grow from increased business activity; construction unions get high-paying jobs, and the expansion of white-collar jobs usually follows the topping out ceremonies. Taxpayers benefit from architectural triumphs such as the Sears Tower, the John Hancock Building, and the Prudential, which generate huge tax increases that fall into the city coffers and ease the tax burden on homeowners. Finally, tourists and out-of-town shoppers flock downtown to view and patronize the rebuilt city; they keep the turnstiles turning at the cultural venues and the cash registers ringing in the fancy upscale and rebuilt North Loop shopping district.

Unlike many Northern cities (e.g., Detroit and St. Louis), whose downtown areas went into serious decline, Chicago's mayors headed growth coalitions and have worked hard to maintain, build, and rebuild the Loop, a viable central business district. The current building boom is clearly a mid-century to millennium phenomenon, for it began with the Prudential Building in 1955 (the first skyscraper since the Great Depression of the 1930s) and has continued to the

end of the century. In fact, Chicago's old Loop has become, in the words of urbanologist Louis Masotti, a "Super Loop," expanding north and west of the Chicago River.

Race and ethnic consciousness soared for whites and blacks during the 1960s and 1970s. Since then, Latino and Asian immigration has surged, along with some increase in Eastern European immigration. This added foreign-born newcomers to the socio-political mix and replaced some of the old black-white tension lines with a more diffuse multiculturalism. As this book shows, Chicago mayors have always been fast on their feet when faced with the issue of cultivating friends through ethno-cultural "identity" politics.

The mayor is not only the city's principal administrator and executive officer, but he must also function as a glad hander and welcome visiting dignitaries, dukes, princesses, counts, and sometimes, "no-accounts" as well. It all comes with the territory. Chicago mayors (with the possible exception of pro-German "Big Bill" Thompson, who was accused of snubbing French hero Marshal Joffre on his visit to the Windy City during WW I) have been particularly adept at greeting visitors. We have provided a goodly sampling of the Windy City's chief political executives "rolling out the red carpet" for Queen Elizabeth, Princess Diana, Nelson Mandela, Bishop Tutu, Mikhail Gorbachev, Frank Sinatra, Mohammed Ali, and others. The wheels on Chicago's welcome wagon have always been "greased and ready to roll."

The Chicago story, from mid-century to millennium, reminds one of an old French saying: "the more things change, the more they are the same." The mid-century decade began with Mayor Richard J. Daley in 1955 at the helm, and now, finishing out the end of the century is another Daley, Richard M. (his eldest son). There have been some significant changes, however; reform, the death of the last big-city machine, a shifting demography, and a new post-industrial economy have made the city different. Still, Chicago remains for most of its citizens a city that prides itself on boldness, toughness, and not being New York. Though its historic broad shoulders may now reveal some tailoring—due to a greater reliance on being a service economy city—the photos in this book clearly reveal Chicago "was still on the make" in the last 50 years of the 20th century.

One
Campaigning for Mayor of Chicago

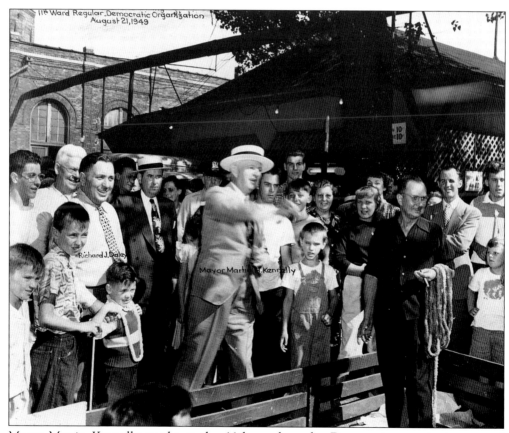

Mayor Martin Kennelly speaks at the 11th ward regular Democratic organization annual picnic and outing in August 1949. Looking on without his suit coat is 11th ward Democratic committee member Richard J. Daley. In less than six years, Daley would succeed Kennelly as Chicago mayor and begin his legendary two-decade run guiding and governing the city. (Courtesy Holime Collection.)

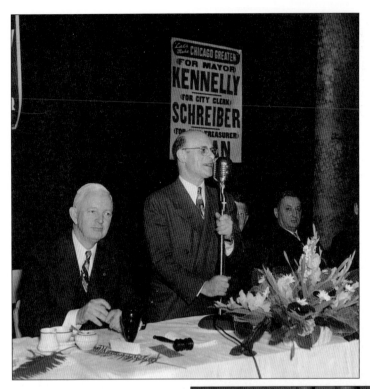

Chicago political boss Jake Arvey is seen at the microphone pushing Martin Kennelly, the first of his "blue ribbon" candidates, for mayor in 1947. Later, Arvey would engineer the election of two other blue ribbon types, Professor Paul Douglas to the U.S. Senate and Adlai Stevenson to governorship of Illinois in 1948. His political fortunes, however, were reversed in a series of defeats in 1950, and Arvey's power in the Chicago political organization declined. (Courtesy Kennelly for Mayor Collection.)

Mayor Martin Kennelly stands beside Alderman Duffy (seated), one of the centers of political power in the Democratic party. They were sometimes called irreverently by their rivals, led by Jake Arvey, the "Irish Turkeys from Beverly." (Courtesy Kennelly for Mayor Collection.)

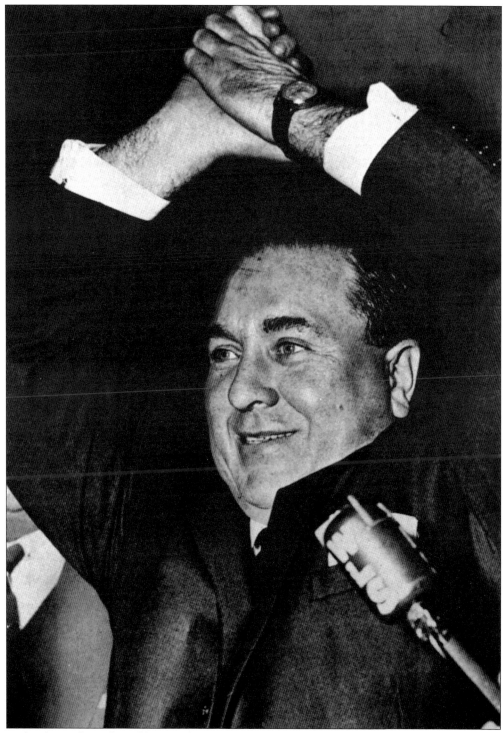
Richard J. Daley, who seldom made such histrionic gestures, poses as the champ on election night in 1955. His great ambition achieved, Daley would speak softly on his desire to "embrace mercy and walk humbly with my God." (Courtesy *Chicago Sun-Times*.)

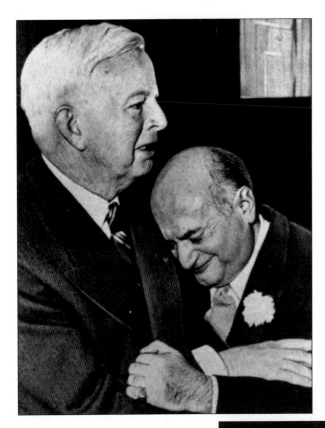

Popular merchant Morris B. Sachs, who was defeated along with the incumbent mayor, is seen weeping on Mayor Kennelly's lapel, lamenting the loss to the Daley machine in the February 1955 Democratic primary election. (Courtesy M. Kennelly.)

"All is fair in love and war." Here, a less disconsolate Morris Sachs is sporting a big, political smile for the occasion, along with the new Democratic nominee for mayor. Daley, recognizing Sachs's vote-getting ability, talked the clothier into taking a vacancy on Daley's own ticket, which went on to win the mayoralty election on April 5. (Courtesy *Chicago Sun-Times*.)

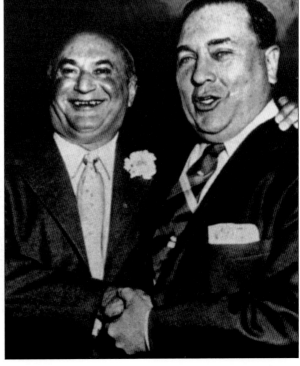

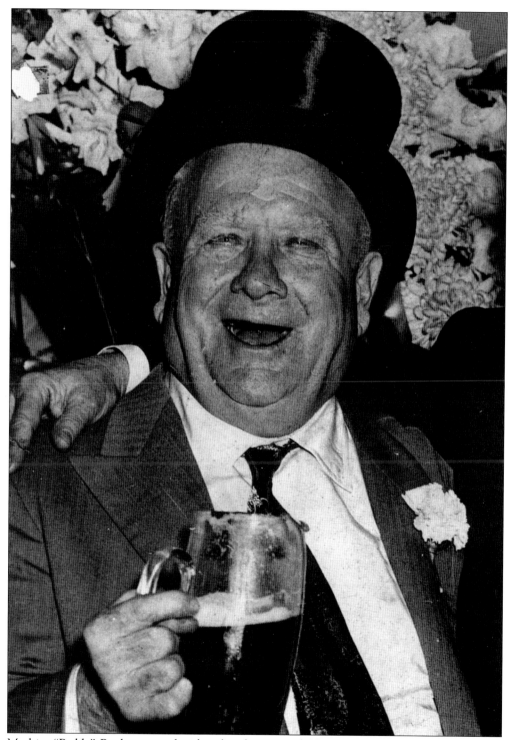

Mathias "Paddy" Bauler, a north-side saloonkeeper and 30-year veteran of the Chicago City Council, appears here with his beery smile and silk top hat. Bauler was famous for his 1955 quote, "Chicago ain't ready for reform yet." (Courtesy Holime Collection.)

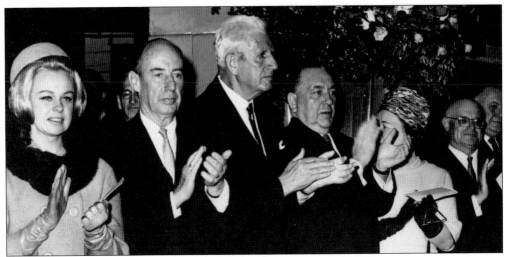

Pictured is a line-up of Democratic political heavyweights who led their party throughout the 1950s and 1960s in Illinois and Chicago. From left to right, they are as follows: Rosalie Clark, wife of Illinois Attorney General William Clark; Adlai Stevenson, Illinois governor from 1948 to 1952 and Democratic presidential nominee in 1952 and 1956; U.S. Senator Paul Douglas, who served from 1948 to 1966; Mayor and Mrs. Richard J. Daley, who served from 1955 to 1976; and Jacob Arvey, former Cook County democratic chairman and Democratic national committeeman from Illinois. (Courtesy Rosalie Clark Collection.)

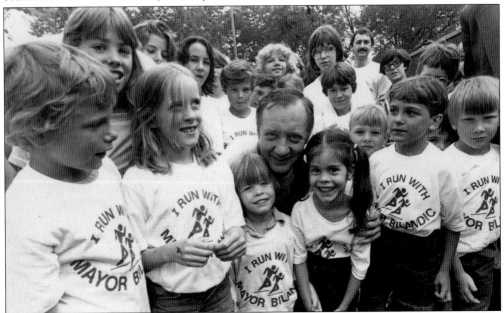

Michael Bilandic became mayor of Chicago following Richard J. Daley's death in December 1976. An avid jogger, Bilandic was not a good political mixer; this picture clearly shows him at ease, however, with dozens of young runners. Bilandic had the unenviable task of following a Chicago legend. Though Bilandic won a special mayoral election in 1977 to serve out the rest of Daley's term, he lost the 1979 Democratic mayoral primary to Jane Byrne. It was a contest that had snow removal as its dominant issue. (Courtesy City of Chicago Graphics and Reproduction Center.)

A Salute to Precinct Captains

There goes an old fellow knee high to a toad
 And wearing a two foot grin
Ringing the doorbells on our block
 And the rain running off his chin.

They say he's been doing it for years on end,
 With ne'er a complaint nor a sigh,
Pushing his party's candidates
 Though their fortunes be low or high.

Some say he does this to hold his job,
 For he has a small job at the Hall,
But he seems to like the things that he does,
 Says canvassing is no hardship at all!

He's ready to share your troubles with you,
 And do most any old thing —
From having the garbage picked up on time —
 To a loan for a wedding ring.

There are others just like him throughout the town
 Who are just the salt of the earth.
They are known as Precinct Captains
 And their value has exceeding great worth!

Some are Republicans and some are Dems;
 But all get the votes in the box.
And without their help the votes would be few
 And government would be on the rocks.

So here's a cheer for the Precinct Captain
And a cheer for his helpers, too,
And a cheer for all good government
And three cheers for the Red, White and Blue!

George A. Lane
(Read at 49th Ward Democratic Organization Dinner — October 16, 1963).

This testimonial to the door-knocking, problem-solving, and vote-producing political worker known as the precinct captain was written during the heyday of Chicago's Democratic Machine. (Courtesy George Lane.)

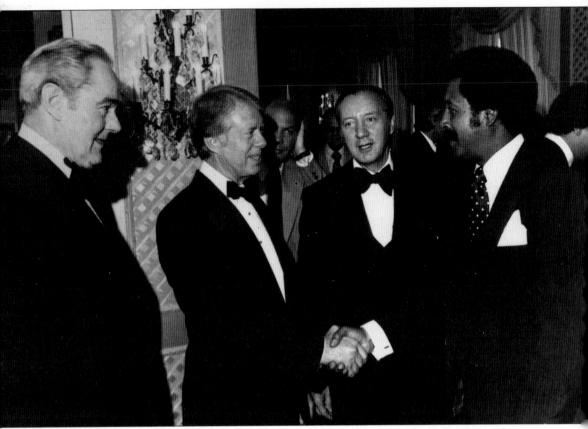

Pres. Jimmy Carter joined Mayor Bilandic at a Democratic Party fund-raiser in Chicago. Standing beside Carter is George Dunne, chairman of the Cook County Democratic Party and president of the Cook County Board of Commissioners. Dunne had a cool relationship with the new mayor. Also standing beside Bilandic is Alderman Eugene Sawyer, the man who would become mayor of Chicago following Harold Washington's death in 1987. (Courtesy City of Chicago Graphics and Reproduction Center.)

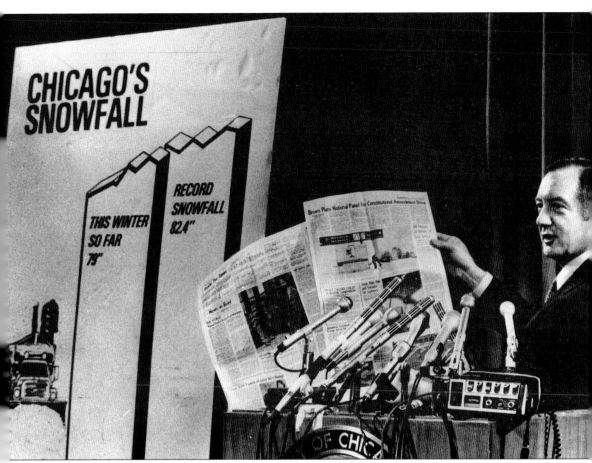

Mayor Michael Bilandic was defeated by Jane Byrne and a record snowfall in 1979. Here, he is seen explaining his administration's inability to cope with snow-clogged streets, a stalled transit system, and sporadic garbage pickup. (Courtesy *Chicago Sun-Times*.)

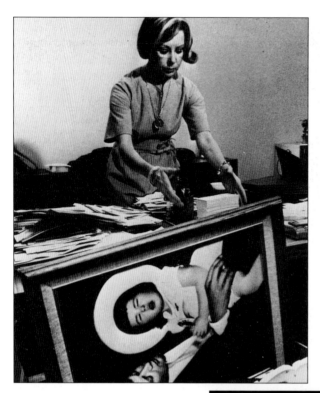

Pictured is Jane Byrne in 1977, cleaning out her office as the city commissioner of consumer sales after she was fired by Mayor Michael Bilandic. Byrne had charged the mayor with improperly "greasing" a taxi-cab fare increase. The picture in the foreground is a snapshot of her daughter with John F. Kennedy. She worked for Kennedy in the 1960 presidential campaign. (Courtesy Byrne for Mayor Campaign Collection.)

Jane Byrne is seen in her 1979 Democratic mayoral primary campaign importuning a truck driver to vote for change. To many, even her close supporters, it seemed like an impossible dream to challenge the Chicago political machine, which, for more than half a century, had picked its nominees without serious challenge. (Courtesy Byrne for Mayor Campaign Collection.)

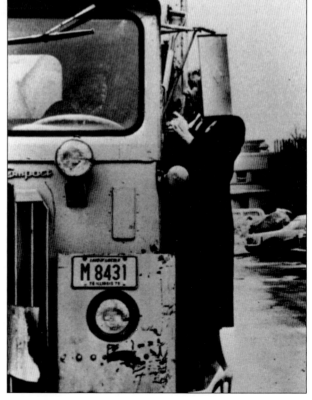

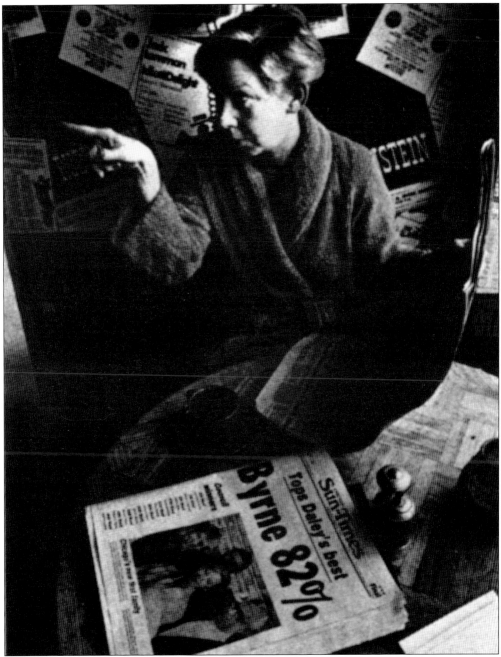
Mayor-elect Jane Byrne savors her mayoral victory while having coffee in her apartment. Her general election plurality of 82 percent exceeded even Richard J. Daley's masterful wins; it was the largest recorded by any 20th-century Chicago Democratic mayoral winner. (Courtesy *Chicago Sun-Times*.)

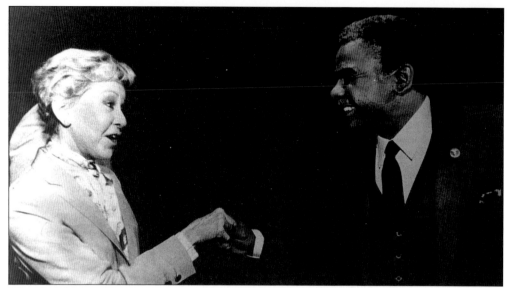

The 1983 Chicago Democratic mayoral primary was the city's political "Super Bowl." Never in Chicago's political past was there a more competitive and brutal fight for power. This ultimate battle was easily the most expensive mayoral contest in history, it had the highest primary turnout and gave Chicago wall-to-wall campaign politics for over three months. This photo shows incumbent Jane Byrne gingerly greeting one of her opponents, Congressman Harold Washington, prior to the campaign's first debate. The third major candidate in this race was then Cook County States Attorney Richard M. Daley. (Courtesy *Chicago Sun-Times*.)

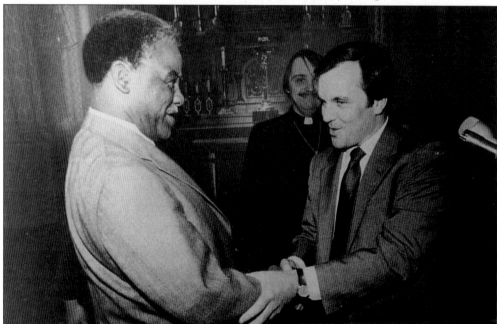

In late January, as the three-way Democratic mayoral campaign became emotionally charged, States Attorney Daley and U.S. Congressman Washington attempted to defuse racial feelings in a joint rally held at the First Lutheran Church, which was located on Daley's home turf, in the Bridgeport neighborhood. (Courtesy *Chicago Sun-Times*.)

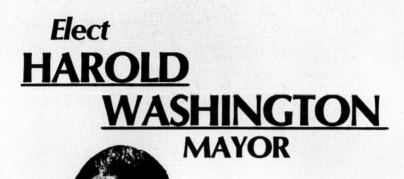

Mayoral primary elections in Chicago have historically pitted the "outs" and "near outs" against the "ins." Harold Washington brilliantly played the outsider role in energizing his African-American vote base. (Courtesy Holime Collection.)

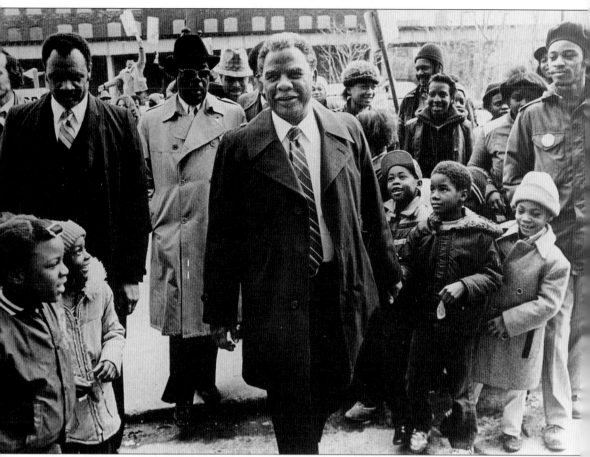
Washington campaigned diligently in the city's predominantly black communities. Pictured here, three days before the primary, he attracted a crowd at 22nd and State Streets. By this time, Washington had become more than a black mayoral candidate, he had attained the status of a black folk hero. (Courtesy *Chicago Sun-Times*.)

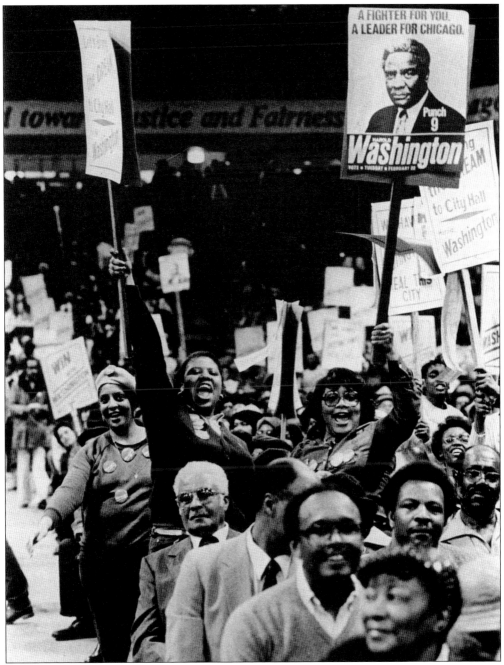
Part of the overflow crowd at Washington's huge Chicago Pavilion rally reflects some of the religious-political fervor during the spring of 1983 that turned the campaign into a "Black crusade." (Courtesy *Chicago Sun-Times*.)

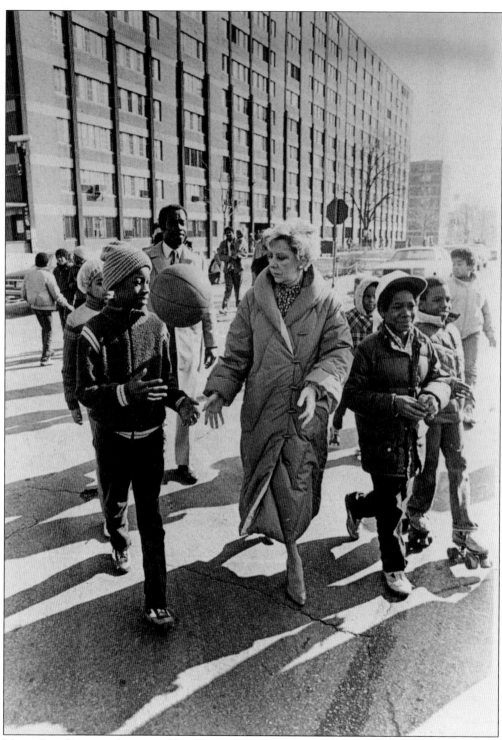
Mayor Jane Byrne made national headlines when she temporarily moved into the city's toughest public housing project, Cabrini-Green. Here, she campaigns among her erstwhile neighbors showing her political—as well as athletic—abilities. (Courtesy *Chicago Sun-Times*.)

Chicago's first female mayor, Jane Byrne, actively sought the woman's vote during the primary. Here, an energetic Byrne speaks to a large crowd gathered in her upper-middle-income home neighborhood, Sauganash, on the city's northwest side. (Courtesy *Chicago Sun-Times*.)

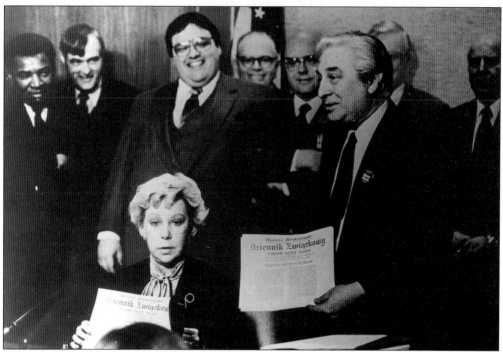

Mayor Jane Byrne pitched her appeal to the ethnic communities during the primary. Pictured above, Byrne received the endorsement of the Polish newspaper, *Dziennik Zwiazkowy*. To the right is 41st Ward Alderman Roman Pucinski, with Budget Director Anthony Fratto at center and Alderman Wilson Frost on the left. (Courtesy *Chicago Sun-Times*.)

During the primary, Richard M. Daley eagerly sought votes in the City's liberal lakefront wards. At this Ash Wednesday Belmont Hotel rally, Daley is joined by State Senator Dawn Clark Netsch, County Board President George Dunne, and 43rd Ward Alderman Martin Oberman. (Courtesy *Chicago Sun-Times*.)

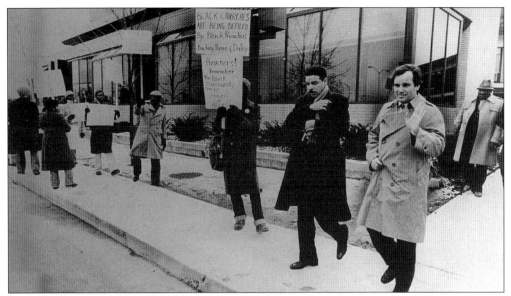

In the 1983 primary campaign, State's Attorney Richard M. Daley wrongly believed that he could garner a sizable portion of the City's black vote. Daley is seen here leaving a breakfast meeting after receiving the endorsements of 75 black ministers. The looming electoral disaster facing white candidates among black voters is captured in the angry protest signs of black pickets chastising their clergy for not supporting Harold Washington. (Courtesy *Chicago Sun-Times.*)

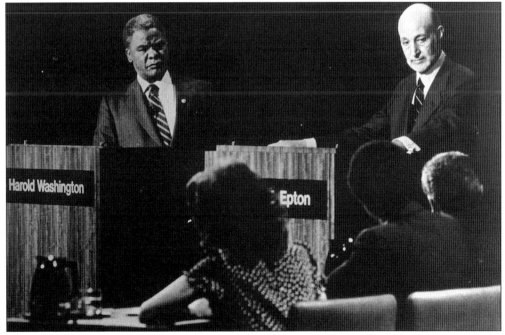

In the 1983 general mayoral election, both candidates Democrat Harold Washington and Republican Bernard Epton appear very serious in their one and only face-to-face debate. Washington had become the Democratic nominee by edging Byrne and Daley in the hotly contested mayoral primary. (Courtesy *Chicago Sun-Times.*)

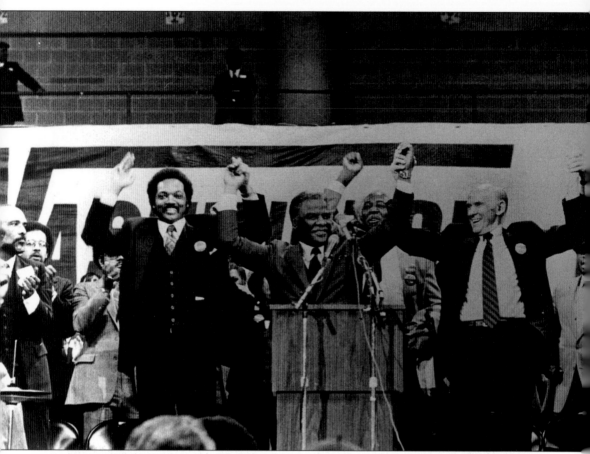

Candidate Harold Washington (center) celebrates his February 1983 mayoral primary victory with Jesse Jackson (left) and Senator Alan Cranston of California. (Courtesy University of Illinois at Chicago.)

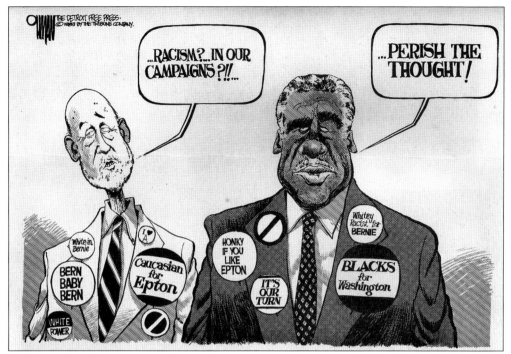

A *Chicago Sun-Times* cartoon depicts the extreme racial overtones of the Harold Washington-Bernard Epton 1983 Chicago mayoral election. (Courtesy *Chicago Sun-Times*.)

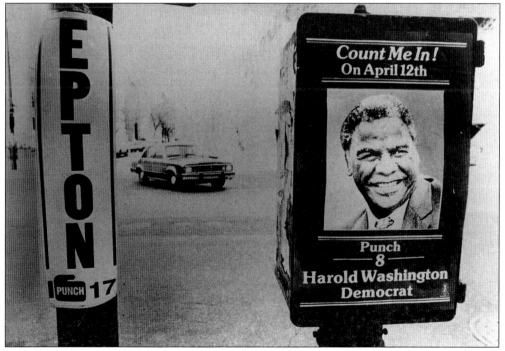

In this rare photo, Epton and Washington campaign posters are seen side by side on a south side street corner. Most neighborhoods featured either one or the other, depending upon the ethnic composition of the community. (Courtesy *Chicago Sun-Times*.)

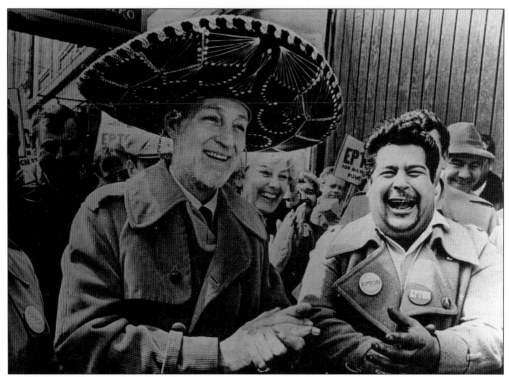
Most political experts considered the Hispanic vote up for grabs in the Epton-Washington contest. Here, the Republican mayoral candidate dons a sombrero in the heart of Chicago's Mexican community at 18th and Blue Island Avenue. In the background, his supporters shouted "viva Epton." (Courtesy *Chicago Sun-Times*.)

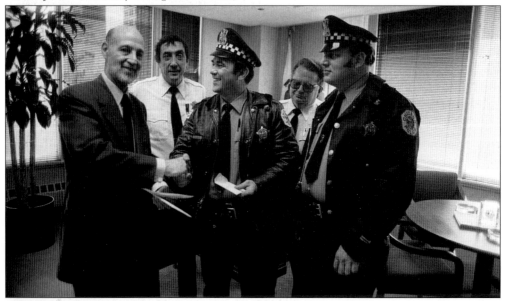
Candidate Bernard E. Epton became a popular choice of many Chicago police officers after Harold Washington made a campaign promise to fire Police Superintendent Richard J. Brzeczek. (Courtesy Lee Balterman.)

Baby kissing is a time-honored political ritual. Here, candidate Epton is seen bestowing an affectionate hug on the offspring of a potential Republican voter. (Courtesy Lee Balterman.)

During the last week of the mayoral general election, Harold Washington campaigned heavily in the independent, liberal lakefront wards. Many voters there were considered undecided, and the Democratic nominee knew he had to carry a sizable bloc to win. Pictured is a Washington supporter who reveals what many Chicagoans thought: the campaign had "gone to the dogs." (Courtesy *Chicago Sun-Times*.)

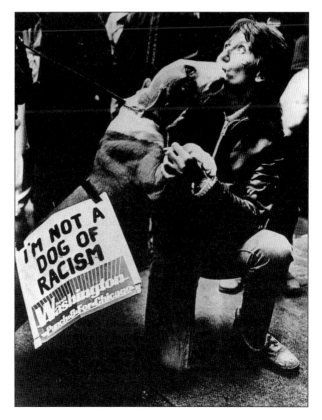

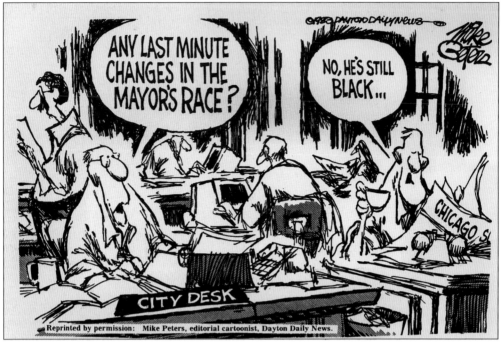

The media's reporting strategies exaggerated inflammatory comments, and, in fact, projected a racially focused campaign from the moment Washington entered the race. (Courtesy Collection.)

The day after, at a post-election "unity" breakfast, Mayor-elect Harold Washington dines with his vanquished foes. From left to right are Judge Saul Epton (who substituted for his brother), defeated Republican candidate Bernard E. Epton, Jane Byrne, Harold Washington, and Richard M. Daley. (Courtesy *Chicago Sun-Times*.)

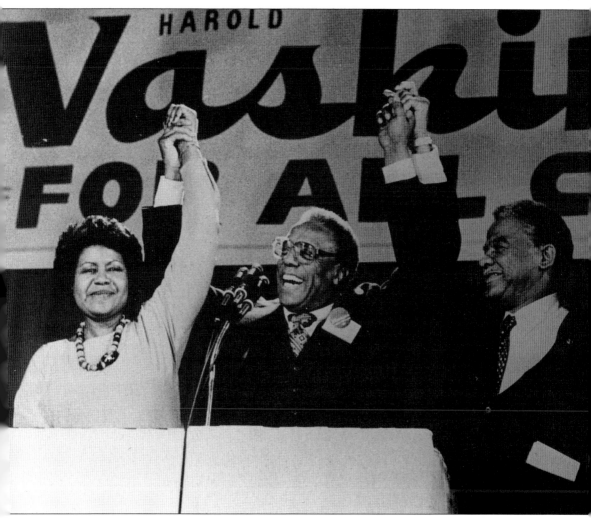

This photo captures the ecstasy of victory felt on election night in April 1983. State Senator Richard Newhouse (center) raises the hands of Harold Washington, Chicago's first black mayor, and the mayor's fiancée, Mary Smith. (Courtesy *Chicago Sun-Times*.)

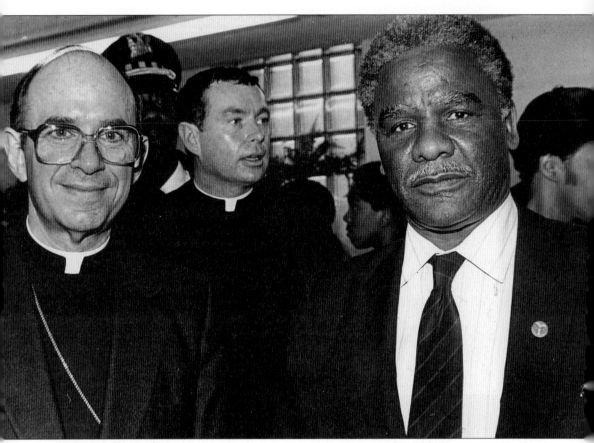
Healing the wounds in a very Catholic city, mayoral winner Harold Washington visits with Chicago's prince of the church, Joseph Cardinal Bernardin. (Courtesy Al Cato.)

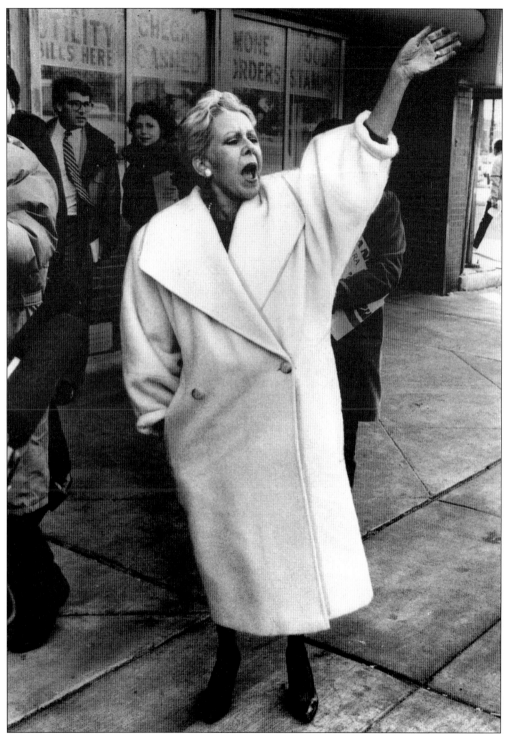
In 1987, former mayor Jane Byrne renewed her rivalry with Mayor Harold Washington in the Democratic mayoral primary. Even though she usually seemed very shy, Byrne was outspoken and aggressive on the stump. (Courtesy *Chicago Sun-Times*.)

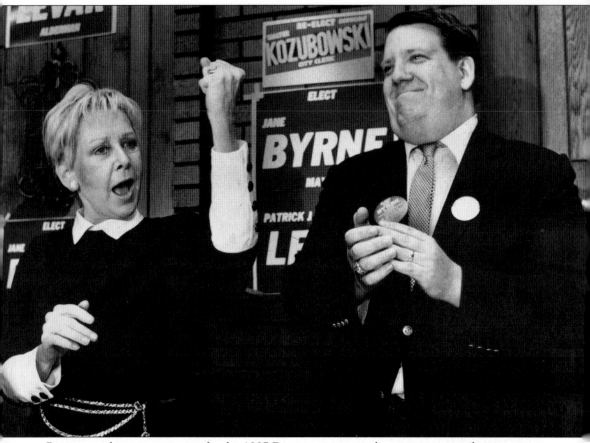

Byrne, seen here campaigning for the 1987 Democratic mayoral nomination, tried to recapture some of the feisty combativeness that had won her the mayoralty eight years earlier. In this view, she is speaking at a northwest side senior citizens' home along with 45th ward aldermanic candidate Patrick Levar. (Courtesy *Chicago Sun-Times*.)

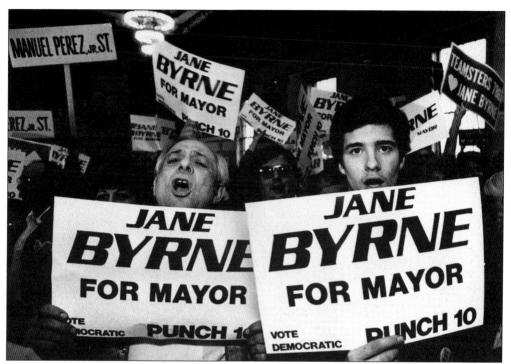

A few days before the primary, Teamsters Local 705 endorsed Byrne's candidacy. (Courtesy *Chicago Sun-Times*.)

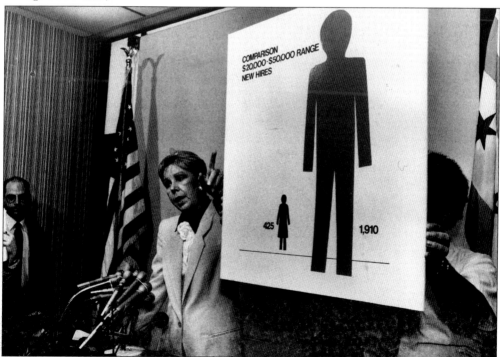

Byrne is shown here at her so-called "gender gap" press conference, where she attacked Washington for not hiring more women to do city jobs. (Courtesy *Chicago Sun-Times*.)

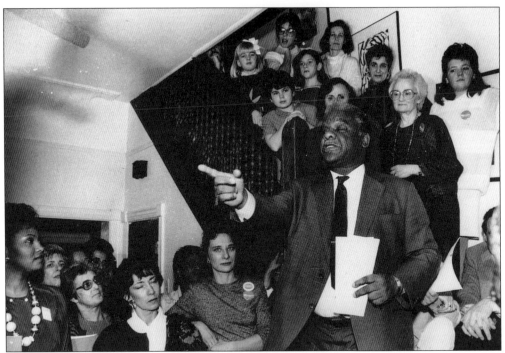
Harold Washington responds to the "gender gap" issue, surrounded by women working in his administration. (Courtesy *Chicago Sun-Times*.)

Mayor Harold Washington exuded charm and wit at social gatherings, even if it was in the midst of a campaign. Here he is seen "schmoozing" with Chief Justice of the Illinois Supreme Court William G. Clark. Seen in the background is another Illinois Supreme Court judge, Seymour Simon. (Courtesy Rosalie Clark Collection.)

Chicago Mayor Harold Washington and Illinois State Senator Howard Carroll (right) discuss with a shopkeeper a rash of anti-Semitic vandalism that had occurred in his heavily Jewish Rogers Park community. The liberal Jewish vote in Chicago had been crucial to Washington's first mayoral victory. (Courtesy *Chicago Sun-Times*.)

Operation CONDUCT, a non-partisan group brought into being by the Community Renewal Foundation and the American Jewish Committee, worked hard and successfully to curb racial, religious, and ethnic slurs in the 1987 mayoral campaign. The balloons in the cartoon record verbal slips of the lip on both sides of the racial divide in the 1987 Democratic mayoral primary and the general election. (Courtesy American Jewish Committee.)

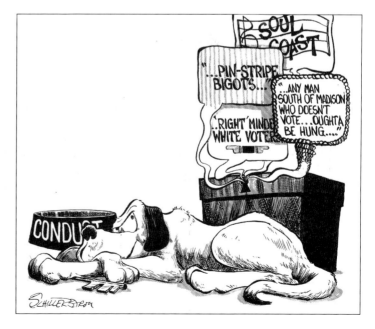

Jane Byrne is campaigning on primary election day "old-fashioned style," in an attempt to soften her image with Chicago voters. (Courtesy Byrne for Mayor Collection.)

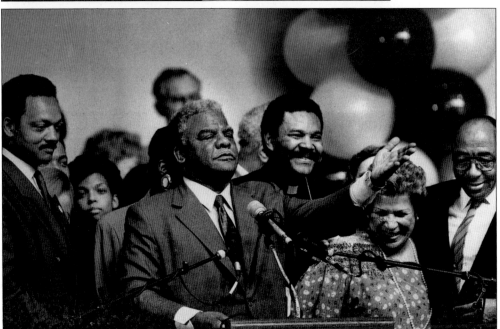

Harold Washington claims victory in the 1987 mayoral primary, surrounded by three important supporters. They are, from left to right, as follows: Rev. Jesse Jackson, Rev. B. Herbert Martin (his pastor), and City Treasurer Cecil Partee. (Courtesy *Chicago Sun-Times*.)

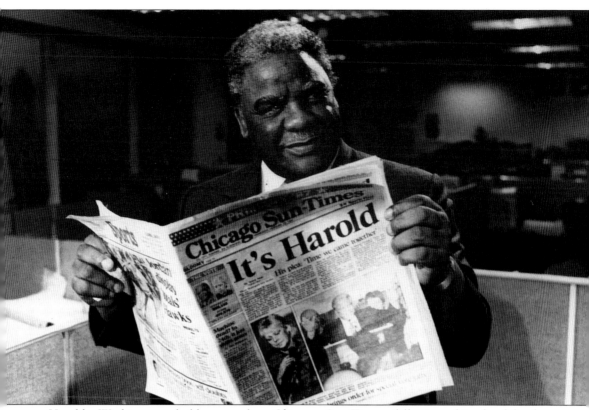
Harold Washington holds up the *Chicago Sun-Times* following his hard-fought 1987 Democratic mayoral primary win against former Mayor Jane Byrne. (Courtesy *Chicago Sun-Times*.)

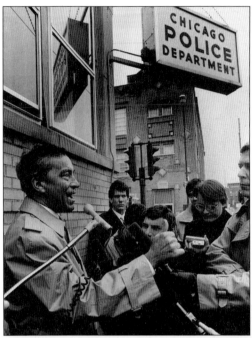

Harold Washington's aldermanic nemesis, Ed Vrdolyak, ran against the mayor as a third-party candidate in the 1987 mayoral election. In this photo, a snarling Vrdolyak denounces a Washington administration proposal to close a near west side police station because of budgetary constraints. Throughout his campaign, Vrdolyak portrayed the mayor as being weak on law enforcement and public safety issues. (Courtesy *Chicago Sun-Times*.)

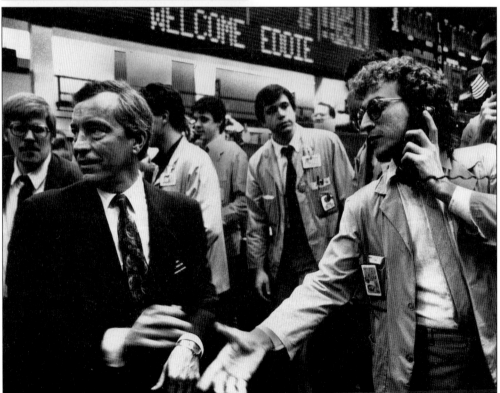

Candidate Edward R. Vrdolyak receives a warm welcome from members of the Chicago Mercantile Exchange. Vrdolyak was a classic example of Chicago's "street smart" politicians who loved playing political hardball. (Courtesy *Chicago Sun-Times*.)

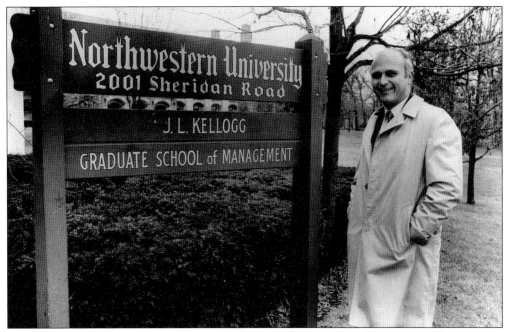

Northwestern University Professor Don Haider was the 1987 Republican mayoral candidate. A knowledgeable and noted academic, Haider elevated the level of debate during the 1987 campaign. (Courtesy *Chicago Sun-Times*.)

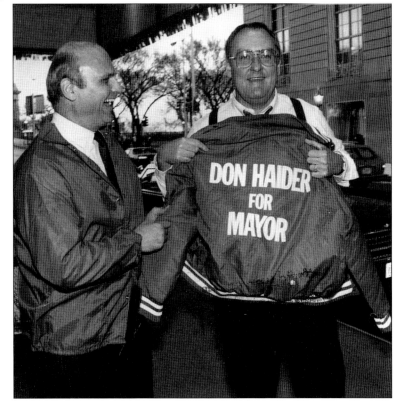

Candidate Haider, always low on campaign funds, spent his remaining campaign budget on a case of red jackets to put his candidacy before the public. Here, Illinois Republican Gov. James Thompson displays Haider's most visible campaign advertisement. (Courtesy *Chicago Sun-Times*.)

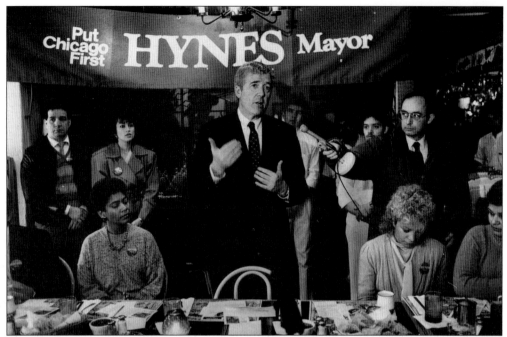

Longtime Cook County Assessor Tom Hynes temporarily left his strong Democratic party roots behind by announcing his third-party candidacy for mayor in 1987. Hynes's Chicago First Party candidacy created few waves, and he dropped out of the mayoral race a few days before the election. (Courtesy *Chicago Sun-Times*.)

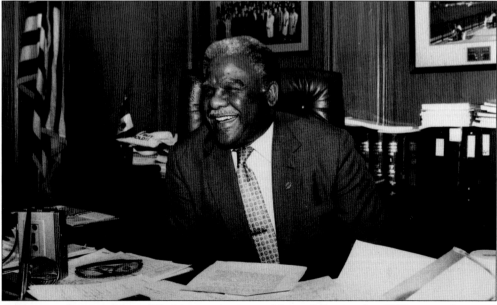

A happy and secure Mayor Washington is pictured here, following his 1987 mayoral victory over Ed Vrdolyak and Don Haider. Washington, who once referred to himself as "a sepia Daley," loved his job as much as his illustrious predecessor had. "He salivates when he gets up in the morning," a close friend said, "looking for something political to do." Washington predicted that he would, like Daley, serve 20 years in that office. (Courtesy *Chicago Sun-Times*.)

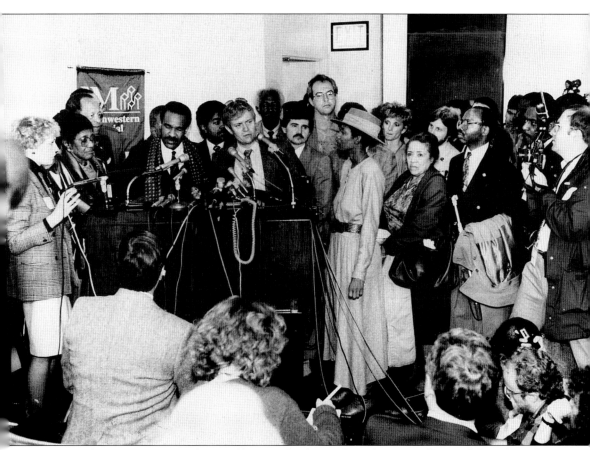
Mayoral Press Secretary Alton Miller, amid a host of Washington allies and friends, sadly announces the death of Harold Washington at 1:30 p.m. on Wednesday, November 25, 1987. (Courtesy *Chicago Sun-Times*.)

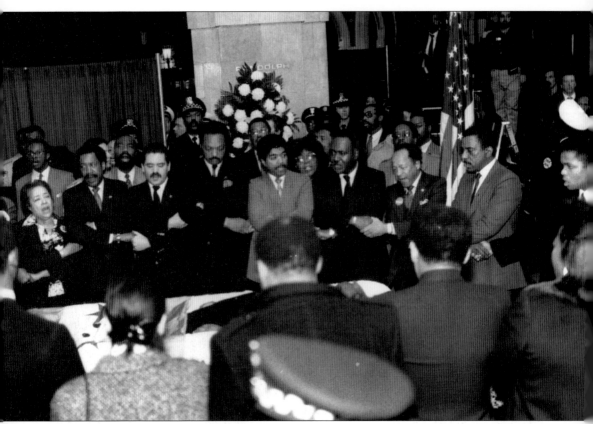
Chicago's black political leaders hold hands as they mourn the fallen chief. Once Washington was buried, many of these same mourners would engage in a ferocious fight for succession to the mayor's chair. (Courtesy *Chicago Sun-Times*.)

Washington's solemn funeral procession winds its way to the church for the final requiem service. (Courtesy *Chicago Sun-Times*.)

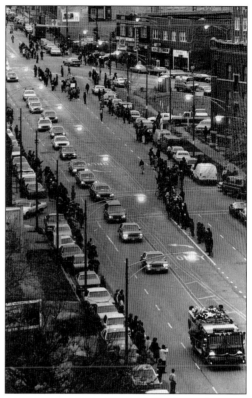

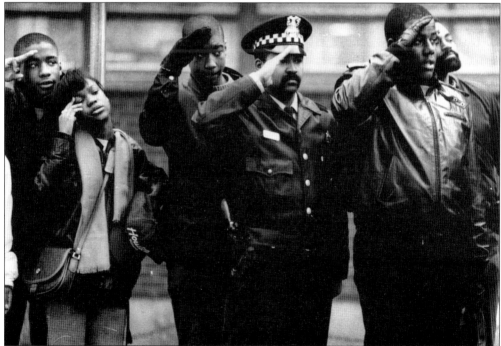

Black Chicagoans, young and old, were deeply touched by the death of Chicago's first black mayor. (Courtesy *Chicago Sun-Times*.)

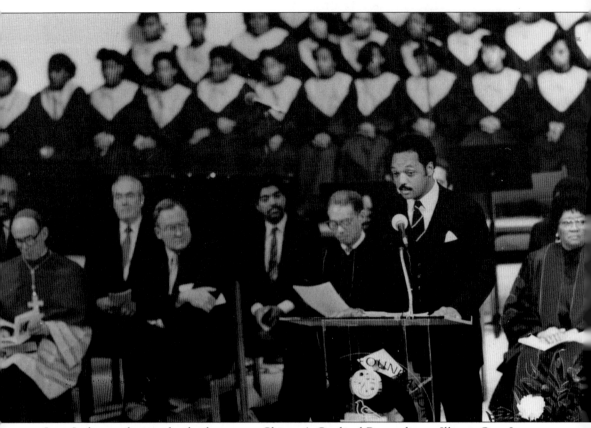
Jesse Jackson eulogizes the dead mayor as Chicago's Cardinal Bernardin, as Illinois Gov. James Thompson listens. (Courtesy *Chicago Sun-Times*.)

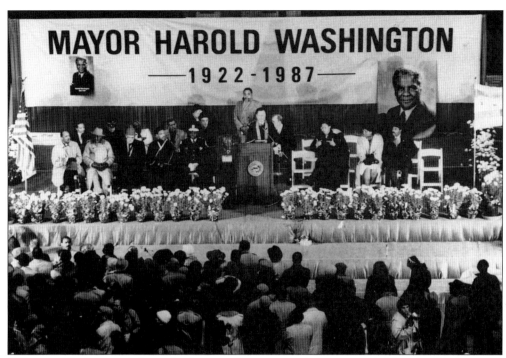

Following Washington's funeral, a huge public memorial service was held at the University of Illinois at Chicago's Pavilion. Unfortunately, it was turned into a political pep rally by many of the speakers, who hoped to name the next mayor. (Courtesy *Chicago Sun-Times*.)

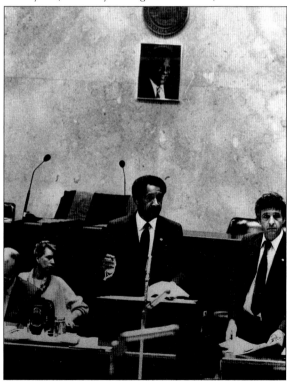

A weary and embattled acting mayor, Eugene Sawyer (1987–1989), who was flanked by corporation counsel Judson Miner, a former political opponent in the succession battle, takes charge of the Chicago City Council. (Courtesy *Chicago Sun-Times*.)

A less than confident alderman, Eugene Sawyer seeks the support of his council colleagues to be named acting mayor following Washington's death. Sawyer was picked to be acting mayor by a bi-racial coalition at 4 a.m. on December 2, 1987, after a stormy night of mob scenes, shouting, and protests reminiscent of banana-republic politics. (Courtesy *Chicago Sun-Times*.)

Mayor Eugene Sawyer (right) and Police Superintendent Leroy Martin stand outside Wrigley Field (home of the Chicago Cubs) prior to the first night game held at the field. Sawyer was instrumental in pushing through an ordinance that allowed the Cubs' management to put lights in the ballpark. (Courtesy Monroe Anderson Collection.)

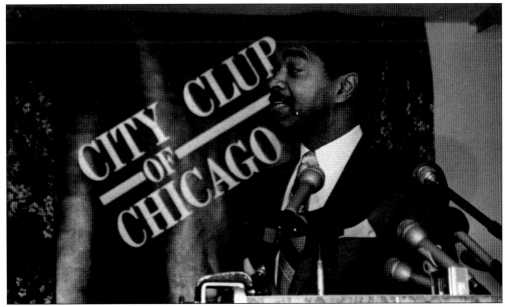

Due to Harold Washington's death, a special mayoral election was held in 1989. Here, candidate Ald. Tim Evans (#4) tells members of the City Club of Chicago why he would be a better mayor than his rivals. Evans, Washington's council floor leader, was unable to capture the magic of the late mayor. (Courtesy Don Neltnor, City Club.)

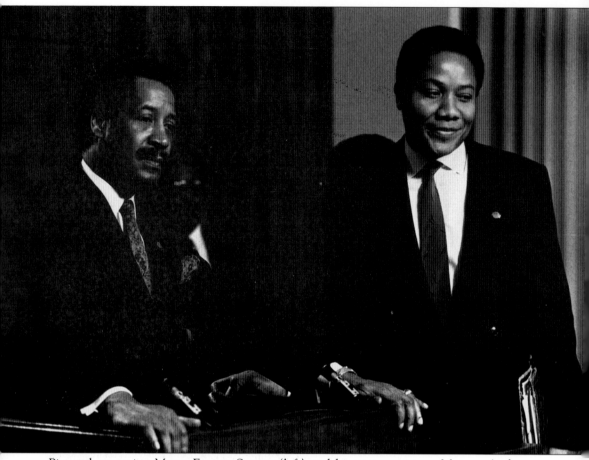
Pictured are acting Mayor Eugene Sawyer (left) and his press secretary, Monroe Anderson. Sawyer, in a brief 16-month term and working under immense political pressure, turned in a creditable record of pushing through a much needed tax increase, breaking a taxi monopoly, and getting the ball rolling for development at O'Hare International Airport. (Courtesy Monroe Anderson Collection.)

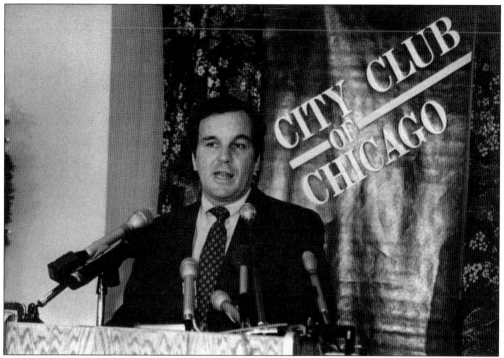

State's Attorney and 1989 Democratic mayoral candidate Richard M. Daley is shown here at the City Club of Chicago, stating his support for radical education reform of the Chicago public school system. (Courtesy Don Neltnor, City Club.)

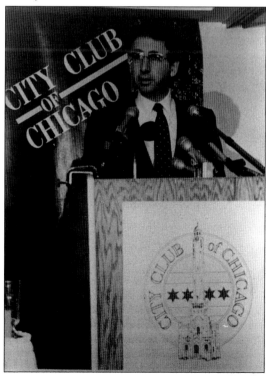

Long-shot Democratic mayoral candidate Ald. Lawrence Bloom (#5) stresses his reform credentials at the City Club of Chicago. Bloom represented Chicago's longstanding liberal Hyde Park community. (Courtesy Don Neltnor, City Club.)

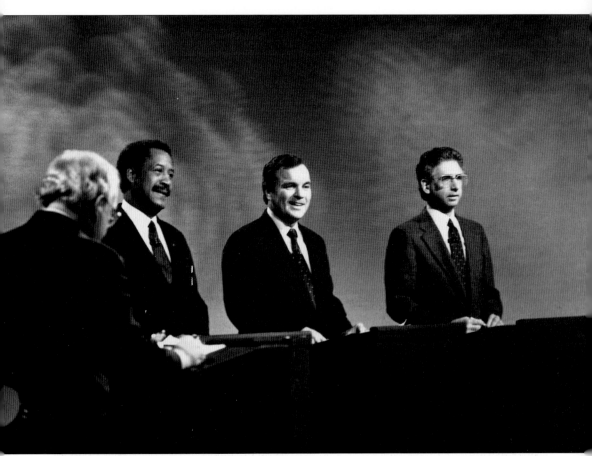

The only televised debate among the 1989 Democratic mayoral primary candidates found Richard M. Daley performing better than expected. The participants, from left to right, included moderator John Callaway of WTTW-TV (back to camera) and candidates Eugene Sawyer, Richard M. Daley, and Lawrence Bloom. (Courtesy *Chicago Sun-Times*.)

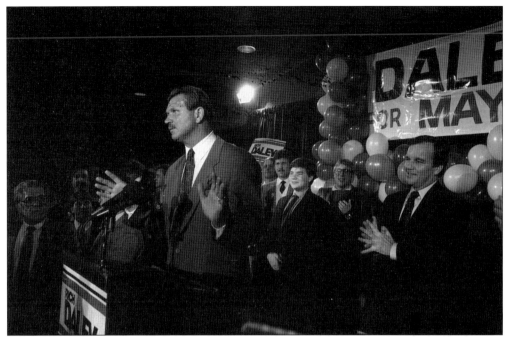

Mike Ditka, coach of the Chicago Bears, is seen here at his well-known restaurant endorsing Daley. (Courtesy *Chicago Sun-Times*.)

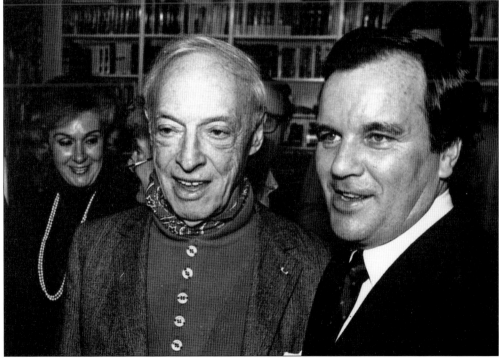

One of the keys to Rich Daley's successful 1989 campaign was his ability to win the support of prominent lakeshore liberals and independents. At a Hyde Park function, Daley posed with his strong supporter, Nobel Prize-winning author Saul Bellow. (Courtesy Office of the Mayor.)

Daley worked the independent-minded lakefront very hard in 1989. Here, he campaigns with some of his major lakefront allies. They are, from left to right, as follows: Daley, State Sen. Bill Marovitz (#3), Ald. Bernie Hansen (#44), and county board member Chuck Bernadini. (Courtesy Office of the Mayor.)

Mr. and Mrs. Rich Daley are shown here attending a Greek Fest gathering that featured the famous Billy Goat Tavern mascot. (Courtesy Office of the Mayor.)

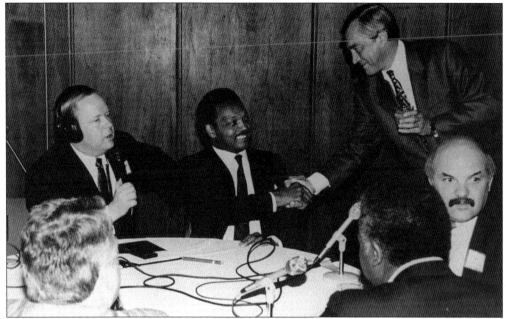

This is definitely a picture for the archives; 1989 GOP mayoral candidate Edward Vrydolak (standing), the late Harold Washington's major nemesis during "council wars," is shown shaking hands with Jesse Jackson during a radio show. Shown with the pair are, from left to right, as follows: Bruce DuMont of WBEZ (with headphones), Sam Panayotovich, 10th Ward GOP committeeman, and (backs to camera) Ald. Danny Davis (#29) and political advisor Phil Krone. (Courtesy Don Neltnor.)

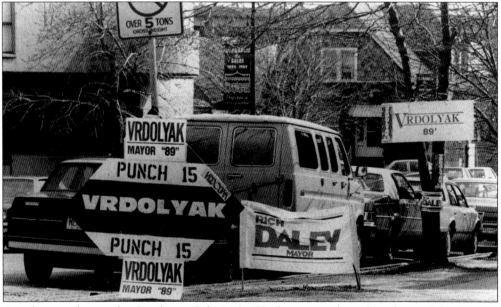

On election day in the Southeast Side 10th Ward, posters abound in front of St. Simeon Serbian Church, a polling place in the heart of Vrdolyak country. Even here, Daley's forces were organized to challenge the once almighty Vrdolyak in his own back yard. (Courtesy Office of the Mayor.)

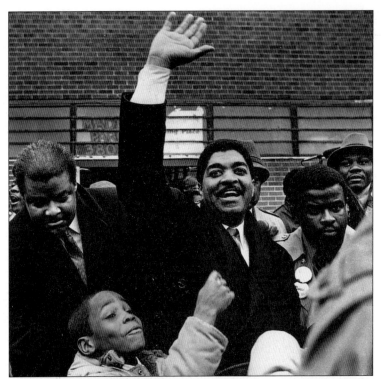

Tim Evans (with arm raised) is shown at the Ida B. Wells public housing project on the South Side, trying to rally black voters behind his independent 1989 mayoral candidacy. (Courtesy *Chicago Sun-Times*.)

Tim Evans is attending a far North Side health fair sponsored by 20 Jewish organizations. During the 1989 campaign, Evans tried hard to ease tensions between the city's African-American and Jewish populations. (Courtesy *Chicago Sun-Times*.)

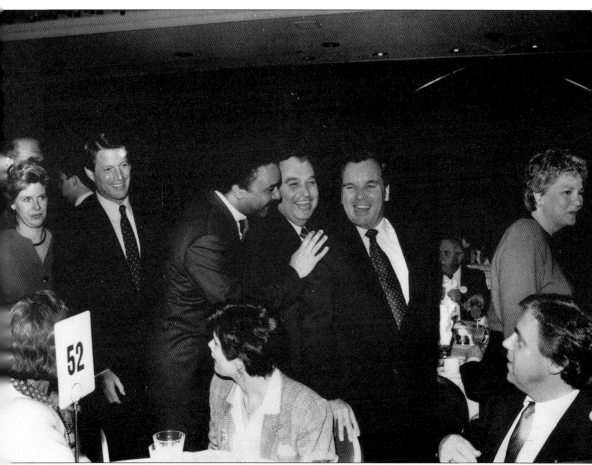

This is a scene from the Democratic Unity Dinner held during the 1989 general mayoral election campaign. The smiling faces are, from left to right, as follows: U.S. Sen. Albert Gore, the keynote speaker; national Democratic parity chairman Ron Brown; Illinois state party chairman Vince De Muzio; and Democratic mayoral candidate Rich Daley. Brown's support of Daley generated much criticism from Ald. Tim Evans's backers in the African-American community. (Courtesy *Chicago Sun-Times*.)

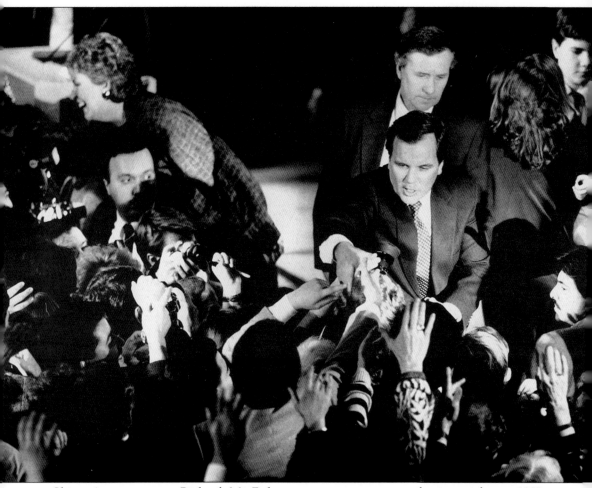

Chicago's new mayor, Richard M. Daley, greets supporters on election night in 1989. Mrs. Daley (top left) is in high spirits after the long, successful campaign. (Courtesy *Chicago Sun-Times*.)

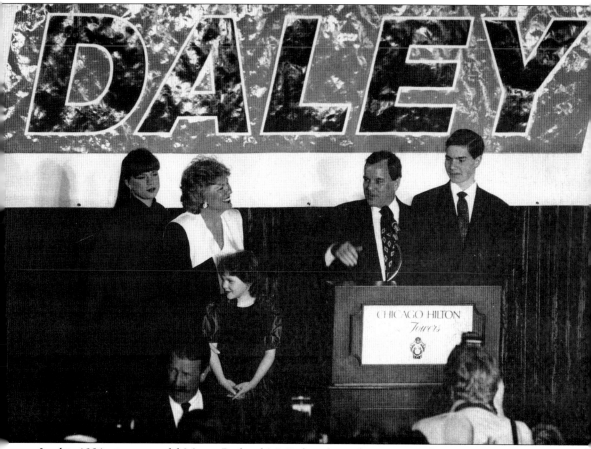

In this 1991 view, a joyful Mayor Richard M. Daley claims his victory. The mayor was easily re-elected to his first full, four-year term in office. (Courtesy Holime Collection.)

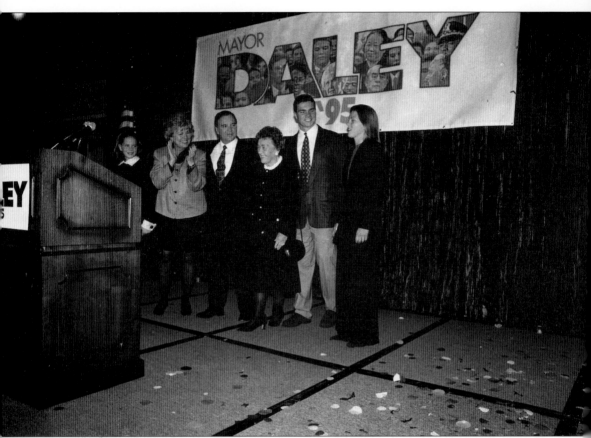
Photographed in 1995, the first family of Chicago, including the mayor's mother, accepts applause from the Daley faithful. By winning his third Chicago mayoral election (1989, 1991, and 1995), Rich Daley had now reached the halfway point of matching his father's record of six mayoral victories. (Courtesy City of Chicago, Press Secretary's Office.)

Two

Administration, Building, and Economic Development

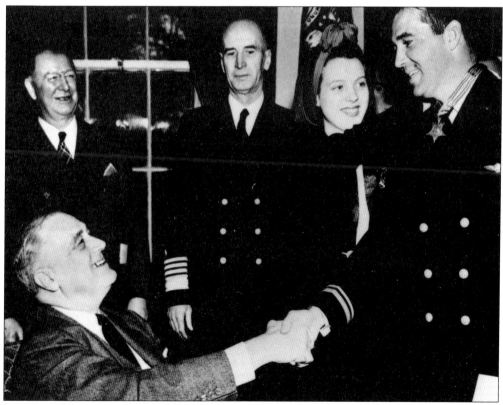

Pres. Franklin D. Roosevelt is shown greeting WW II flying ace Edward "Butch" O'Hare and his wife. O'Hare's name became synonymous with Chicago air travel when the city named its new northwest side main airport after the war hero in the early 1960s. Today, O'Hare airport is a main engine in the city's economic development machine. (Courtesy City of Chicago Graphics and Reproduction Center.)

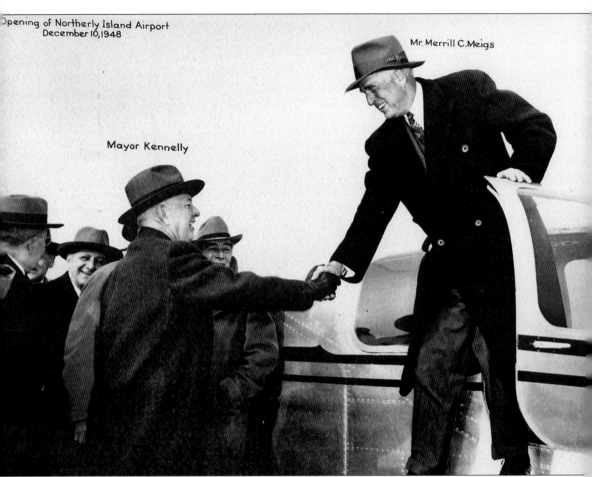

Mayor Martin Kennelly greets Merrill Meigs at the opening of Northerly Island Airport on Chicago south lakefront in 1948. The airport's name would later be changed to Meigs Field to honor the Chicago businessman and longtime airport advocate. In the 1990s, the continued existence at Meigs Field would become a political issue between Chicago Mayor Richard Daley and Illinois Gov. Jim Edgar. (Courtesy Kennelly Collection.)

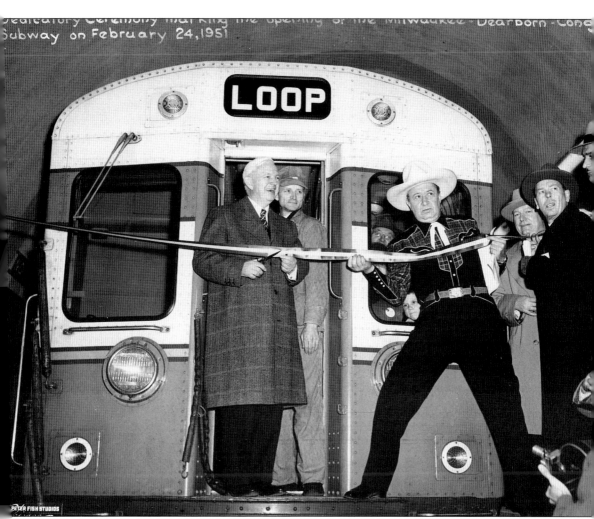
In this early 1951 view, Mayor Kennelly is shown opening the Dearborn Street subway line. (Courtesy Kennelly Collection.)

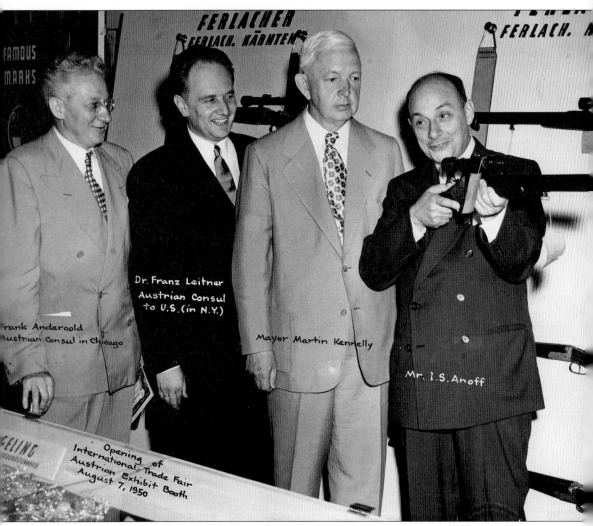

This is a mid-20th-century example of Chicago's desire to be an international center for commerce and trade. Mayor Kennelly and Austrian officials are attending the 1950 International Trade Fair held in the Windy City. (Courtesy Kennelly Collection.)

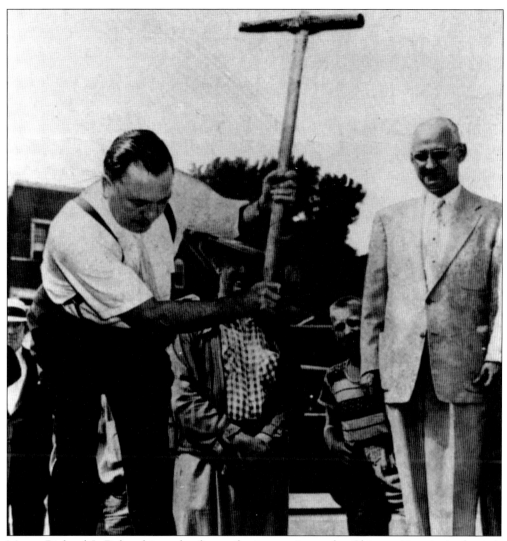
Mayor Richard J. Daley drives the first spike into a tie on the Chicago Transit Authority's new track, which was being laid in the midsection of the city's west side Congress Expressway in 1955. An observant Alderman Vito Marzullo looks on to what will become one of the best integrated big-city transit systems in the nation. (Courtesy Vito Marzullo Collection.)

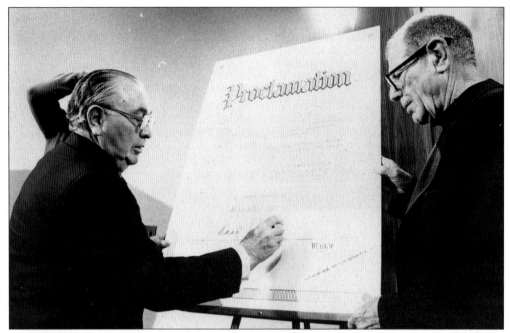

Richard J. Daley, a legendary Chicago White Sox baseball fan, signs a proclamation declaring Bill Veeck day in Chicago. Veeck, the controversial White Sox owner, looks on with appreciation. (Courtesy City of Chicago Graphics and Reproduction Center.)

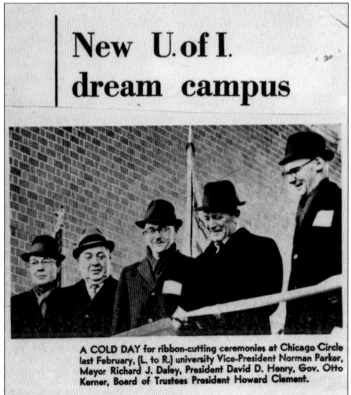

A COLD DAY for ribbon-cutting ceremonies at Chicago Circle last February. (L. to R.) university Vice-President Norman Parker, Mayor Richard J. Daley, President David D. Henry, Gov. Otto Kerner, Board of Trustees President Howard Clement.

It was a cold day for ribbon-cutting ceremonies at the city's new University of Illinois Chicago Circle campus in February 1965. Honorees, pictured from left to right, include university Vice-President Norman Parker, Mayor Richard J. Daley, President David D. Henry, Gov. Otto Kerner, and Board of Trustees President Howard Clement. Daley fought long and hard to establish a four-year U of I campus in his city. (Courtesy *Chicago American*, Feb. 22, 1965.)

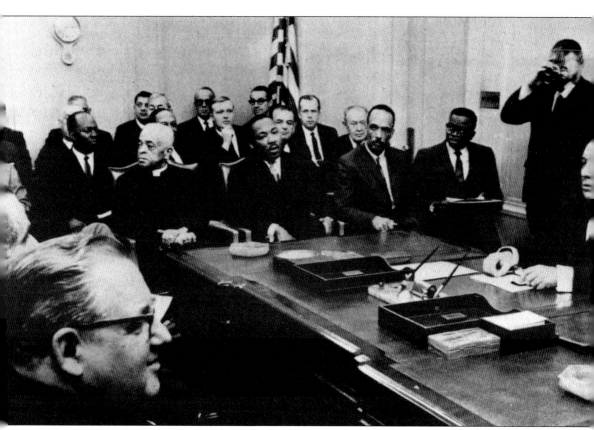

This historic image records the Martin Luther King confrontation with Mayor Richard J. Daley and the "End Slums Now" campaign in the hot summer of 1966. This "summit" conference meeting included Chicago activist Al Raby (on King's immediate right) and Chicago's Catholic Bishop John Cody (foreground). Daley and King eventually reached a compromise that ended the riot-provoking marches and street disorder. (Courtesy *Chicago Sun-Times*.)

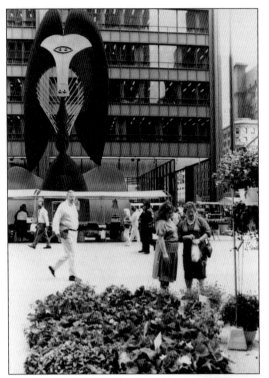

Chicago's famous outdoor Picasso Statue is located in the downtown Richard J. Daley Plaza. Though known nationally as a city of broad shoulders and bare-knuckle politics, Chicago is also a world-class city rich in architecture and art. All Chicago mayors have endorsed and played up the city's grand cultural tradition. (Courtesy City of Chicago, Graphics and Reproduction Center.)

Richard J. Daley, "America's last boss," exuded a twinkling Irish charm, even though he was somewhat flustered by an affectionate Hawaiian tourist representative. (University of Illinois at Chicago Library, Department of Special Collections.)

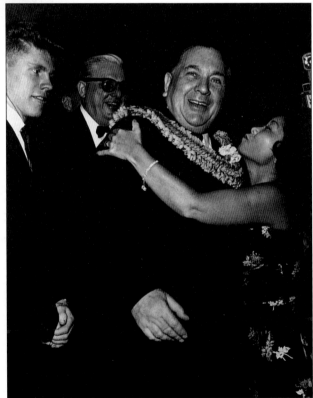

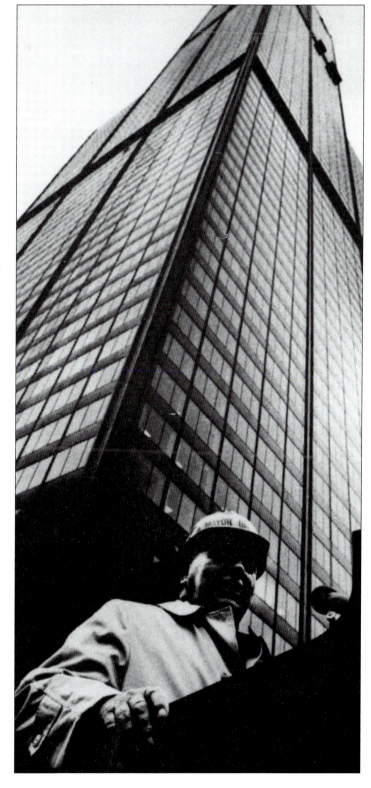

Pictured is Mayor Richard J. Daley on May 3, 1973, at the topping-off ceremony at Sears Tower. Until 1996, it was the world's tallest building. This beehive of human activity brought in 15,000 people to work, shop, and dine in a single building; the skydeck, with its spectacular view of the city's skyline, became a tourist's paradise. Mayor Daley rewrote the "builder mayor" tradition by presiding over the biggest building boom seen in the city since the Great Fire of 1871. Daley and his planning department practiced a hands-on style, with the business community cultivating, watering, and seeding the boom that resulted in many architectural triumphs in the central business district and nearby neighborhoods. New buildings included the John Hancock Building, the Watertower Place, the AMOCO Building, a new city campus for the University of Illinois, and the Sears Tower. (Courtesy Office of the Mayor.)

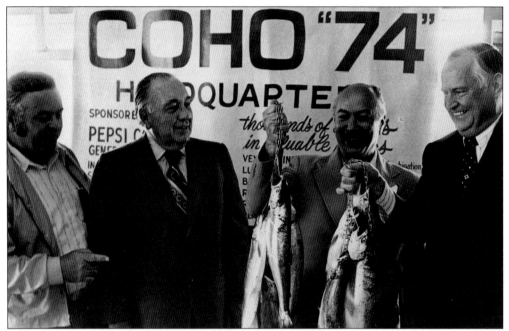

This remarkable photo heralds the recovery of Lake Michigan fishing in 1974. Daley, an avid fisherman, was known on occasion to troll the harbor before going to City Hall. Here, he proudly shows off his morning catch. (Courtesy Edward Kelly Collection.)

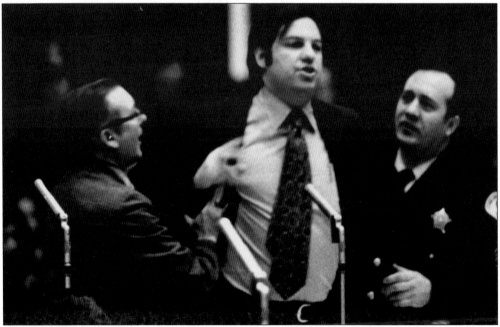

Being an alderman can be stressful. Former 44th alderman and University of Illinois political scientist Dick Simpson is shown challenging one of Mayor Daley's rulings that declared the alderman out of order. Independent Simpson often protested the mayor's authoritarian control of the city council in the 1970s, and in this case was forcibly reseated by the sergeants at arms. (Courtesy Dick Simpson.)

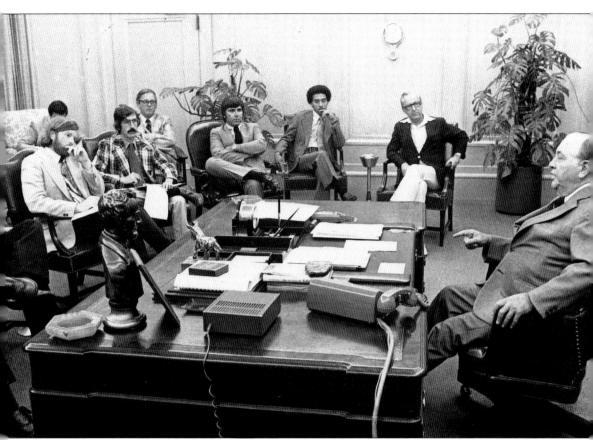

Richard J. Daley lectures a group of young scholars and reporters in his office. Pictured are Bruce Dold of the *Chicago Tribune* (full beard); Louis Masotti of Northwestern University (arms folded); and Jay McMullen (white trousers, Jane Byrne's future husband) of the *Chicago Daily News*. (Courtesy Lou Masotti Collection.)

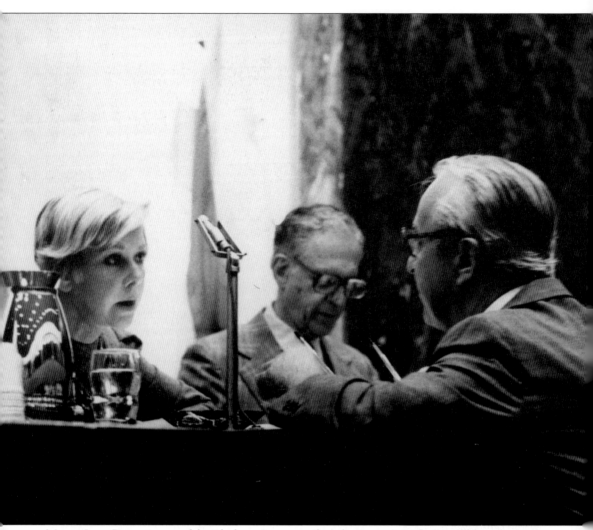
Mayor Jane Byrne is seated beside her city council parliamentarian, former Alderman Leon Despres, while talking strategy with her husband and press secretary Jay McMullen. (Courtesy City of Chicago, Graphics and Reproduction Center.)

Mayor Byrne pensively listens to the words of her new budget director, Donald Haider, a professor on loan from Northwestern University's Kellogg business school. The mayor later tangled publicly with her director over budget matters, and in effect, fired him. Chicagoans are not easily discouraged; Haider entered the mayoral campaign in 1987 as the Republican candidate. (Courtesy *Chicago Sun-Times*.)

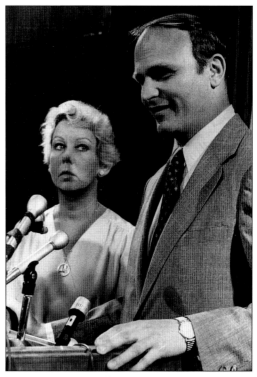

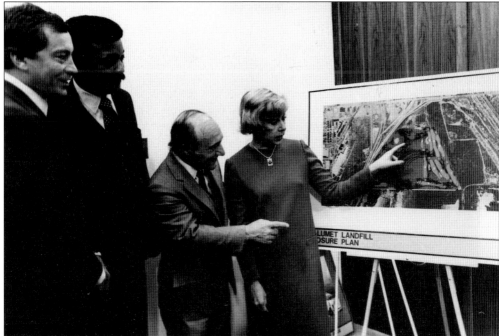

A mayor's responsibilities are far reaching and cover everything from plowing snow to picking up garbage. Here, Mayor Byrne discusses a pending Calumet Landfill Enclosure Plan with the following officials: Alderman Ed Vrdolyak (#10), Alderman Robert Shaw (#9), and Sanitary District Pres. Nicholas Melas. (Courtesy City of Chicago, Graphics and Reproduction Center.)

State Street, Chicago's Great Street, hit on hard times in the late 1970s and early 1980s. In order to revive the street, a State Street Mall was created, and all bus and car traffic was abolished. Unfortunately, the plan flopped. Today, State Street has returned to its traditional hustle and bustle of automobile and pedestrian traffic. Shown here is the city's famous Chicago Theater, which is also trying to be resurrected to its glory days. (Courtesy City of Chicago, Graphics and Reproduction Center.)

This is another view of the State Street Mall. (Courtesy City of Chicago, Graphics and Reproduction Center.)

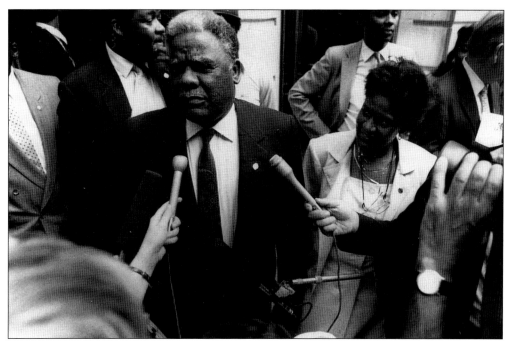

Washington answers questions from the press with his key political advisor and alter ego, Jacky Grimshaw, at his side. Grimshaw was considered by many to be the most politically savvy woman in Chicago politics. (Courtesy *Chicago Sun-Times*.)

Mayor Washington's first year "report card," issued by civic leaders, business leaders, writers, academics, and political consultants was a disappointing overall average grade of B-minus. The mayor disagreed, giving himself an "A." (Courtesy Holime Collection.)

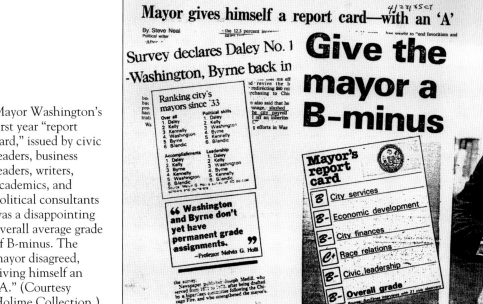

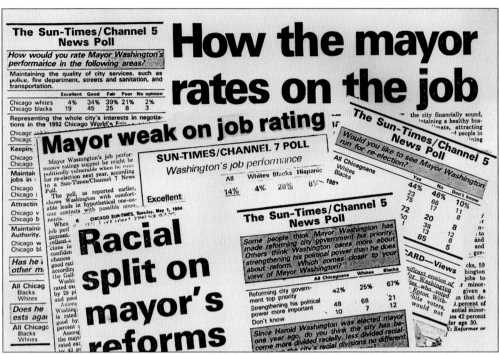

Public opinion polls continued to pick up the mayor's poor job rating for most of his first term, which lasted from 1983 to 1987. (Courtesy Holime Collection.)

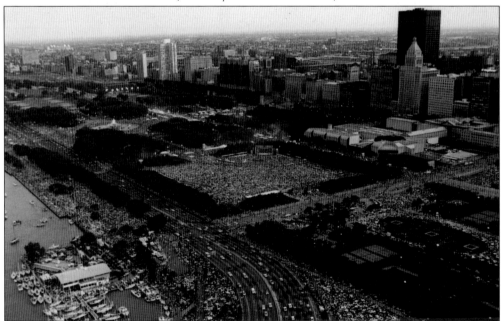

Grant Park, located on Chicago's magnificent lakefront, is used for concerts, civic events, festivals, and Taste of Chicago, which is held every summer. The latter features dozens of Chicago restaurants, various types of music and entertainment, and consistently draws several million attendees over a ten-day period. (Courtesy City of Chicago, Graphics and Reproduction Center.)

When it came to picking his park board, Mayor Washington chose, from left to right, the following members: Jesse Madison, a City Hall loyalist; Rebecca Sive, a professional feminist; Margaret Burroughs, a black museum director; and Walter Netsch, a "limousine liberal" architect. (Courtesy *Chicago Sun-Times*.)

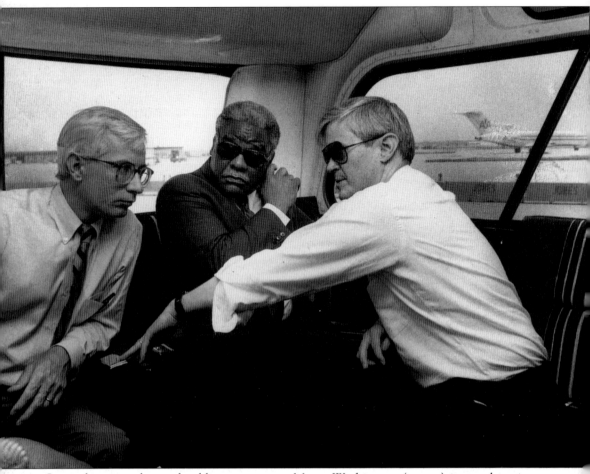
Out making speeches and public appearances, Mayor Washington (center) is seen here in a limo-bus with public works commissioner Paul Karras and his press secretary, Alton Miller (right). (Courtesy Office of the Mayor.)

Washington greets the newest member of his team, Alderman Luis Gutierrez, as they celebrate the critical 26th Ward, judge-ordered, 1986 special aldermanic election that gave Washington control of the Chicago City Council. (Courtesy *Chicago Sun-Times*.)

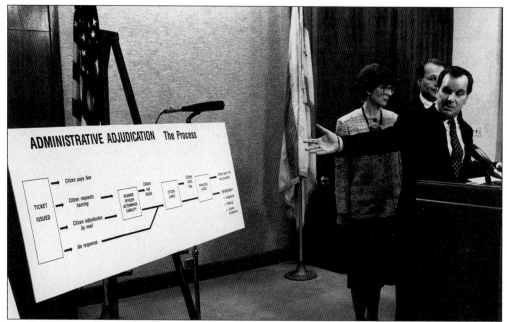

Mayor Richard M. Daley unveils his plans to clean up Chicago's chronic problems with parking enforcement. Daley replaced the old system with F.A.S.T. (Fine Adjudication System for Tickets), a system that generally bypassed the overloaded court system for adjudication and placed the City directly in charge of fine collection. (Courtesy Office of the Mayor.)

Mayor Richard Daley, along with State Senator Robert Molaro and Streets and Sanitation Commissioner Raymond Cachares, announces his revolutionary plan to privatize the towing of abandoned vehicles in Chicago. (Courtesy City of Chicago.)

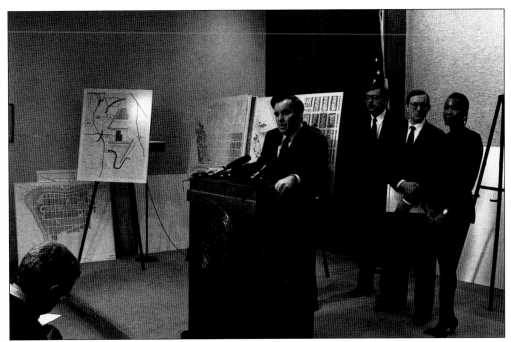

The ill-fated Lake Calumet plan to build a third major airport in Chicago is announced in a Daley press conference. Surrounded by consultants and staff, Daley spoke glowingly about the airport's potential. Unfortunately for Daley, the Illinois General Assembly vetoed the idea. (Courtesy Jim Peterson, Office of the Mayor.)

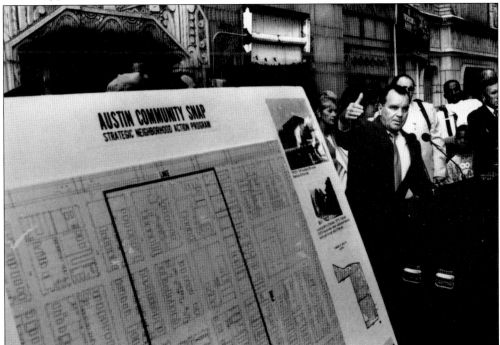

Mayor Rich Daley is seen here describing a neighborhood redevelopment plan in Chicago's West Side Austin community. (City of Chicago, Graphics and Reproduction Center.)

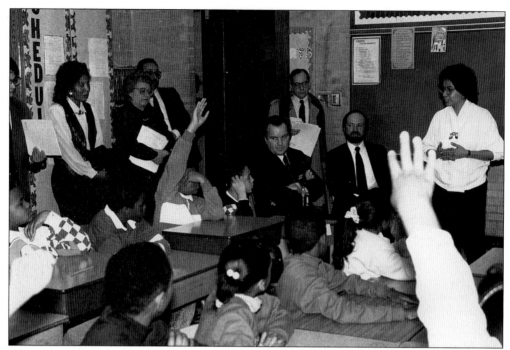

Most Chicagoans want their mayor to be responsible for all aspects of city life. Here, Daley is seen introducing a pilot AIDS education program to fourth graders at a South Side school. (Courtesy Office of the Mayor.)

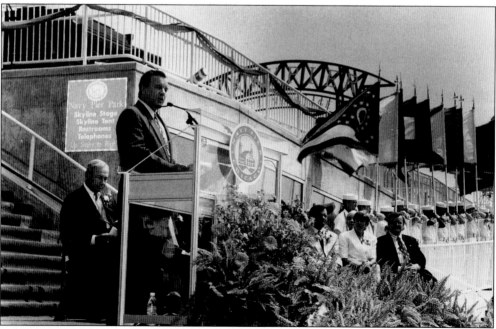

One of Mayor Richard M. Daley's greatest building accomplishments was the renovation of Chicago's Navy Pier on the city's lakefront. Under his direction, Navy Pier, once an urban eyesore, has become Chicago's number one tourist attraction. This photo shows the grand opening. (Courtesy City of Chicago, Press Office.)

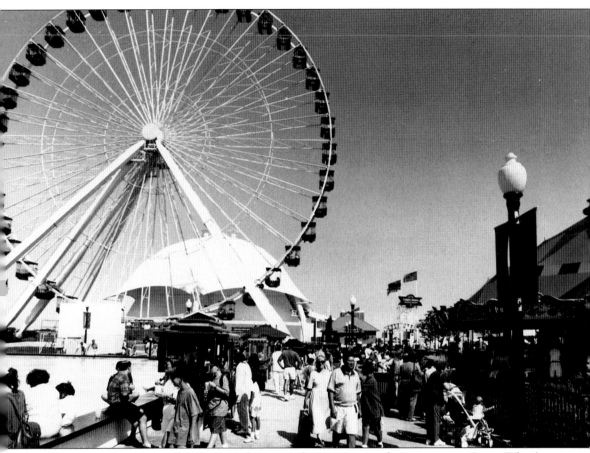
This is another view of the new and improved Navy Pier with its imposing Ferris Wheel. (Courtesy City of Chicago, Graphics and Reproduction Center.)

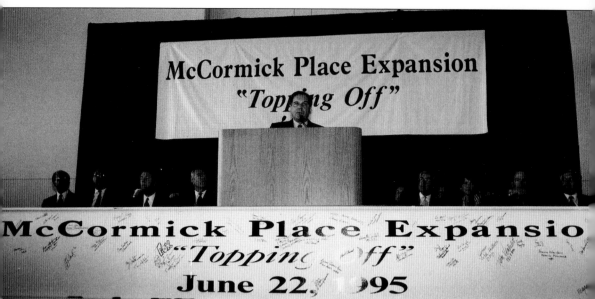

Daley and Illinois Gov. Jim Edgar (seated at the mayor's left) are shown officiating at the McCormick Place Expansion "Topping Off" ceremonies. McCormick Place, Chicago's convention and trade center complex on the lakefront just south of The Loop, has become a vital component in the city's economic development plans. Chicago's national leadership in attracting convention and trade shows is heavily dependent upon a vibrant modern and expanding McCormick Place. (Courtesy City of Chicago, Press Office.)

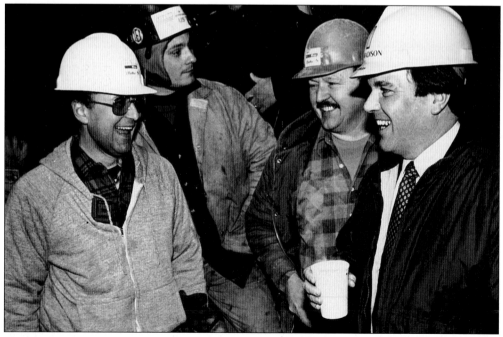

"Builder" Mayor Richard M. Daley is seen here at ground level talking with the "real" builders, construction workers at a Chicago hotel re-development project. (Courtesy Office of the Mayor.)

Pictured in this view is Section 37, a square block in the heart of Chicago's downtown. This land was the former home to lavish movie theaters, restaurants, retail shops, and office buildings. The city has been unable to find suitable developers for this prime land, and in the interim, it has turned Section #37 into a temporary showplace for cultural and artistic events. (Courtesy City of Chicago, Graphics and Reproduction Center.)

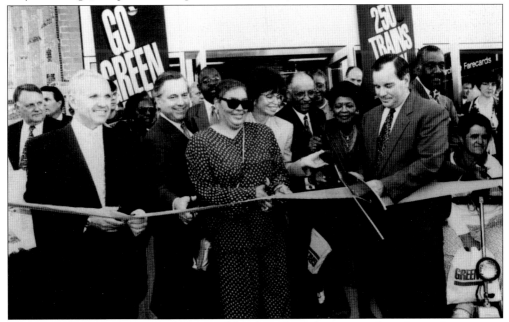

Historically, Chicago's elevated train and bus lines have been critical to the city's economy. Most Chicago mayors have been very pro public transportation. Seen here is Mayor Daley cutting the ceremonial ribbon, opening one of the city's renovated elevated and subway train lines. (Courtesy City of Chicago, Graphics and Reproduction Center.)

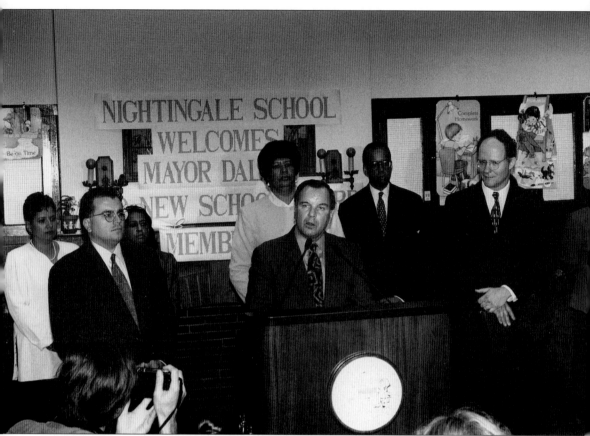

Mayor Richard Daley is seen here introducing Gary Chico (left) as the new head of the Chicago School Reform Board and Paul Vallas as the new CEO of the Chicago Public School system. Both Chico and Vallas were top lieutenants in Daley's administration. In perhaps one of the "gutsiest" moves in Chicago mayoral history, Daley, with Illinois General Assembly approval, took over full responsibility for elementary and secondary public schools in Chicago. By placing Chico and Vallas in charge of this traditional political and policy nightmare for previous mayors, Daley let Chicago know that he would be held accountable for school performance. (Courtesy City of Chicago, Press Secretary's Office.)

Three
ETHNIC AND RACIAL DIVERSITY

Mayor Richard J. Daley honors Judge Fred "Duke" Slater (left) at a Joint Negro Appeal Benefit Dinner. Also pictured is Black community leader Aaron H. Payne. (Courtesy Holime Collection.)

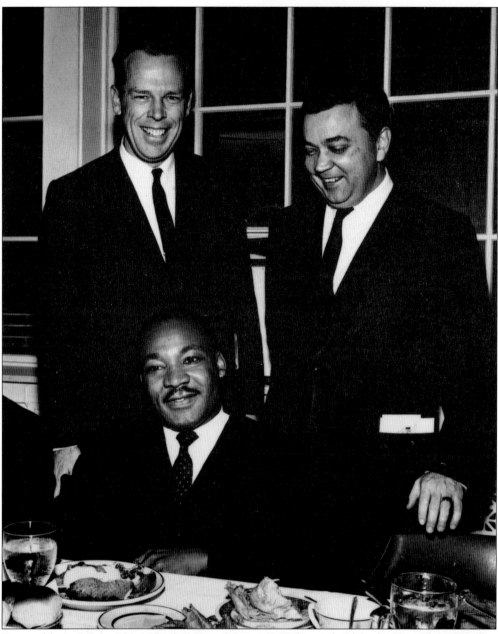
Pictured here is Rev. Martin Luther King Jr. at a 1962 dinner held at the Orrington Hotel in suburban Evanston, Illinois. Looking on is Ed Marciniak, director of Chicago Commission on Human Relations (right) and an unidentified man. (Courtesy Ed Marciniak Collection.)

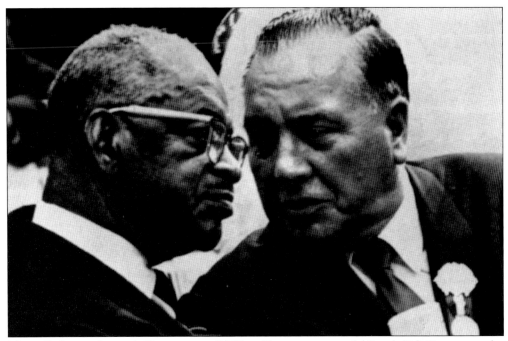

Mayor Daley confers with Congressman William Dawson, a powerful South Side Democrat who ran a mini-machine and played a major role in helping Daley win both the mayoral nomination in 1955 and a hotly contested mayoral election in 1963. Dawson delivered his African-American wards with some of the largest majorities in the city. (Courtesy Urban Historical Collection, Eugene Kennedy File.)

APRIL 5, 1968
King assassination sparks city riots
Weekend of violence, looting leaves scars that still show 3 decades later

Before darkness fell on this day, a Friday, the plumes of smoke from the West Side already were visible to Loop office workers. In Chicago and across the nation, rioting was breaking out in response to the news that Martin Luther King Jr. had been gunned down in Memphis the day before.

On Friday evening, at the beginning of what would become a hellish weekend, commuters jammed Lake Shore Drive in an effort to avoid the chaos along the Eisenhower Expressway.

Many U.S. cities—including Detroit; Newark, N.J.; and Los Angeles—were convulsed by riots in the mid-1960s. Chicago had not escaped unscathed; riots in the Humboldt Park neighborhood in 1966 had seemed major when they happened. Yet the city had been spared the kind of devastation left in the wake of Los Angeles' Watts riots of 1965. With the assassination of King, the city's luck ran out.

Throughout the weekend, police in the Lawndale and Austin neighborhoods on the West Side and in the Woodlawn neighborhood on the South Side rushed from emergency call to emergency call as mobs of men, women and children moved from store to store, breaking plate-glass windows and taking what they found. Television sets, clothing, food and liquor were carted away from largely white-owned businesses that lined Madison Street and Homan and Kedzie Avenues. Fires blazed out of control across the West Side.

Not long after sunset Friday, Army units and the first of 3,000 Illinois National Guard troops arrived to back up police, who had no training for such a civic catastrophe. Military units and fire department crews were greeted by sniper fire, but no soldiers, police or firefighters were killed or seriously hurt. By Saturday afternoon, soldiers in Jeeps bristling with machine guns had secured the overpasses along the Eisenhower from downtown almost to the city's western edge. The fires, shootings and looting continued through Sunday night, but by Monday morning relative quiet had returned.

Mayor Richard J. Daley later told reporters that he had ordered police "to shoot to kill any arsonist or anyone with a Molotov cocktail in his hand . . . and . . . to shoot to maim or cripple anyone looting any stores in our city." In the first two days of rioting, police reported numerous civilian deaths but were unable to determine whether they were caused by the riots or other crimes. No official death toll was given for the tragedy, although published accounts say nine to 11 people died during the rioting. Three hundred fifty people were arrested for looting, and 162 buildings were destroyed by arson. Bulldozers moved in to clean up after the rioters, leaving behind vacant lots that remained empty three decades later.

James Coates
Tribune staff

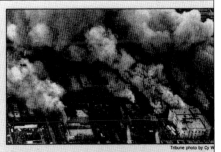

On the first day of rioting, the sky above West Madison Street (above) fills with smoke. Looting also breaks out (left), devastating blocks of West Side shops.

Like many other Northern cities, Chicago suffered several days of rioting following the assassination of Dr. Martin Luther King Jr. in April 1968. Chicago's West Side was particularly hit hard, and the extent of the violence caused Mayor Richard J. Daley to issue one of his most controversial statements of his lengthy career. The mayor ordered police to "shoot to kill any arsonist . . . shoot to maim anyone looting . . ." (Courtesy *Chicago Tribune*.)

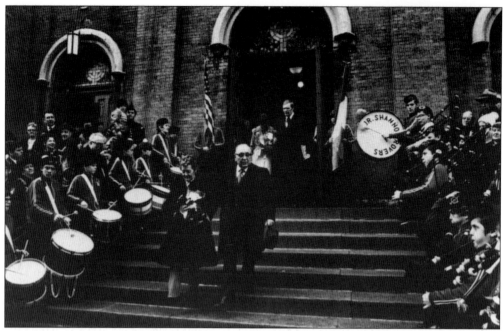
Passing through lines of squealing bagpipers and drummers, Mayor and Mrs. Daley greet the popular marching group, the Shannon Rovers, as they leave St. Patrick's Cathedral for a parade. (Courtesy Office of the Mayor's Press Secretary.)

Shown here are Columbus Day delegates from Italy visiting Alderman Vito Marzullo (left) as they prepare for the Columbus Day Parade. (Courtesy Vito Marzullo.)

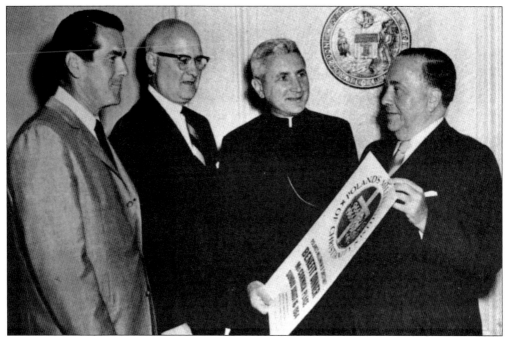

Celebrating 1,000 years of Christianity, Mayor Daley receives a benefit poster from Aloycius Wyceslo as Appellate Court Judge Francis Lorenz (left) and County Treasurer Bernard R. Korzen (right) look on. (Courtesy *Chicago Tribune*.)

A Bolivian-born physician, Dr. Hugo Muriel was the first Latino named to a prestigious position with the City when Mayor Jane Byrne appointed him Chicago Health Commissioner in 1979. (Courtesy *Chicago Reporter*.)

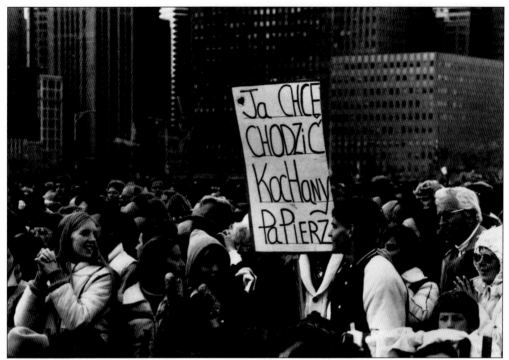

Historically, Chicago has been both a very Polish and Catholic city. These two traditions came together in 1979, when Pope John Paul II visited Chicago. (Courtesy City of Chicago, Graphic and Reproduction Center.)

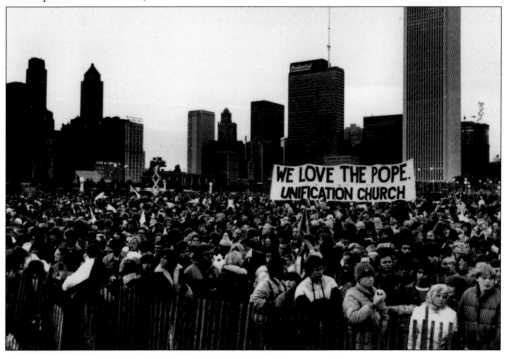

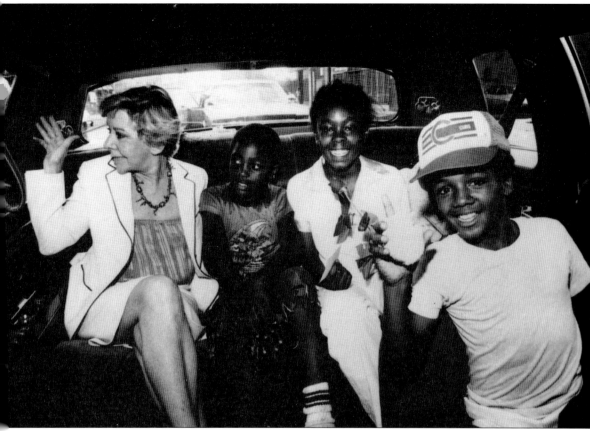
Newly elected Mayor Jane Byrne oozed charisma early in her administration. She had almost instant rapport with the city's poor and minorities. Unfortunately for Byrne, this era of good feelings gave way to an era of ill will between her and these same constituents. This photo shows a glowing Byrne giving delighted youngsters a ride in her limousine. (Courtesy City of Chicago, Graphic and Reproduction Center.)

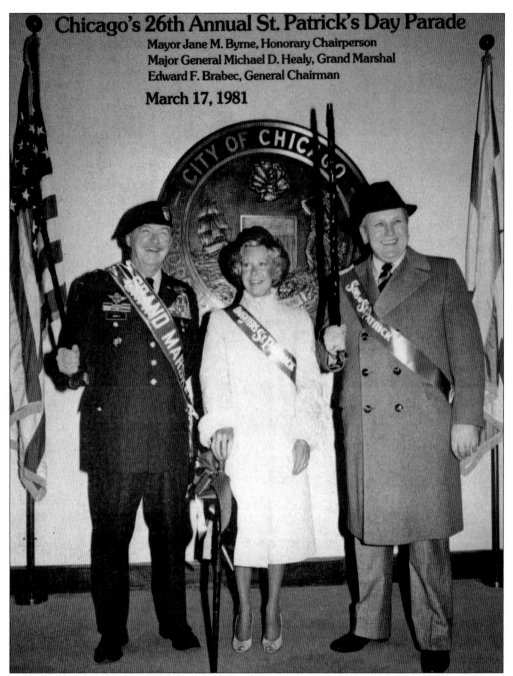

Jane Byrne, like her hero Richard J. Daley, sought to become the city's number one Irishman. She is shown here with U.S. Army Gen. Michael Healy and Parade Chairman Ed Brabec before the 1981 St. Patrick's Day parade. Despite her best efforts, Byrne was never viewed as Daley's heir by a huge portion of Chicago's Irish population. (Courtesy Dan Lydon.)

Whether it is an Irish jig, a Sicilian tarantella, or a Mexican fandango, Chicago mayors learn to be fast on their feet on both the dance floor and in the hustings. Here, "Hizzoner" Daley trips the light fantastic. (Courtesy Office of the Mayor's Press Secretary.)

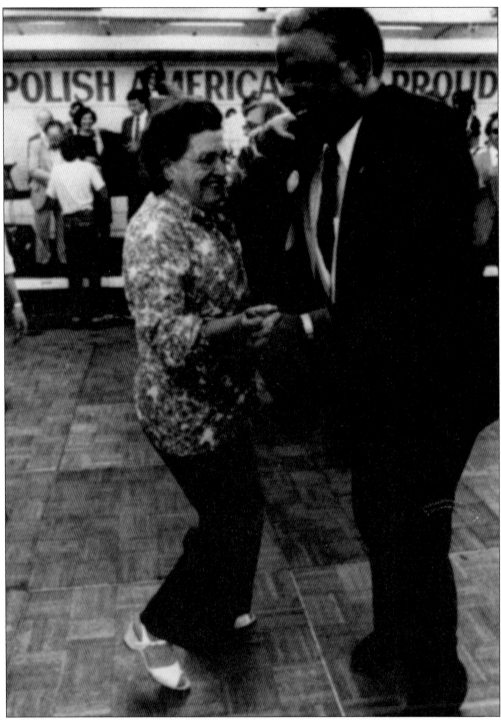
Chicago's first African-American mayor, Harold Washington, dances a polka at a Polish-American community event. Washington's dream was to be accepted as mayor of the entire city, and he was on the verge of healing the racially divisive council war wounds at the moment of his untimely death. (Courtesy Office of the Mayor's Press Secretary.)

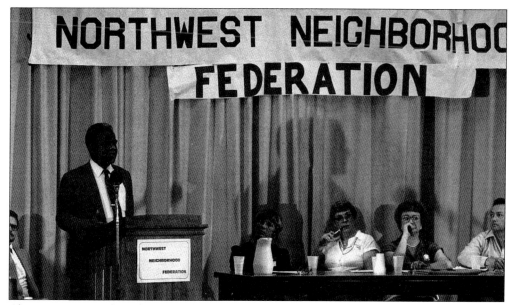

Chicago is a city of neighborhoods where ethno-cultural concerns run high at any change in political landscape. Harold Washington was severely criticized in 1983 for not campaigning among whites until the end of the election. Here, he is seen in a post-election visit to one of the areas where he faced opposition, Chicago's Northwest Side. (Courtesy City of Chicago.)

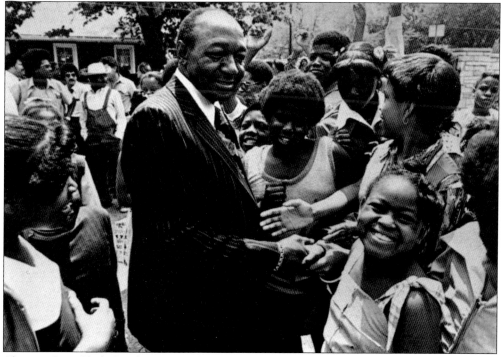

Chicago City Clerk Cecil Partee is shown meeting his constituents in the mid-1970s. Partee was a longtime popular figure and reconciler, and was respected by all of the factions in the racially torn Democratic Party during the hectic Washington mayoral years. (Courtesy Cecil Partee Collection.)

Mayor Eugene Sawyer stands between Irish Consul Gen. Peter Gunning and the St. Patrick's Day Queen in this view. Sawyer, in his years in office, was never able to achieve the aura of mayor in the eyes of many Chicagoans. A quiet and studious man, Sawyer seemed uncomfortable in Chicago's "no-holds-barred" politics. (Courtesy Rosalie Clark Collection.)

Unlike his predecessor Gene Sawyer, Rich Daley quickly learned how to navigate the city's politically charged waters. In this photo, he presents a bouquet of roses to Christine Boehm, the 1989 Von Steuben Day parade queen. Joining the mayor in his office are 47th Ward Alderman Eugene Schulter; Gunther Wasserberg, consul general of Germany; Karl Laschet, vice-president of the United German American Societies; Horst Syferth, vice-president of the Von Steuben Parade Committee; Helen Meiszerner, treasurer of the Von Steuben Parade Committee; and William and Walter Boehm. Mayor Daley proclaimed September 16 as "Von Steuben Day" in Chicago. (Courtesy Mayor's Press Office.)

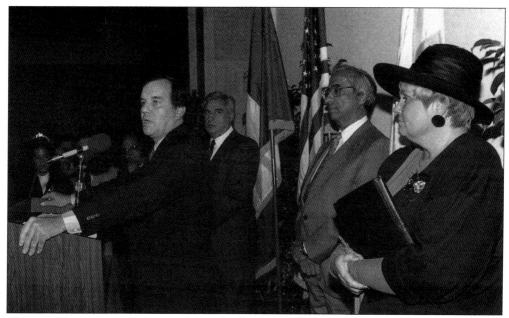

Chinese-American caterers invite Mayor Richard M. Daley to taste cuisine from their homeland during the Chinese New Year Celebration held at Truman College on 1145 West Wilson Street. During the event, which was sponsored by the Chinese Mutual Aid Association (CMA), Mayor Daley said, "This celebration reflects the great spirit, warmth and cooperation that exists between all of Chicago's diverse cultures. I'd like to thank our Asian-American community for contributing to Chicago's cultural richness." Greeting the mayor upon his arrival was Raymond Tu, CMA board president; Bart Moy of the Commission on Asian-American Affairs; and the mayor's close ally, Kathy Ostermann, director of the Mayor's Office of Special Events. (Courtesy Holime Collection.)

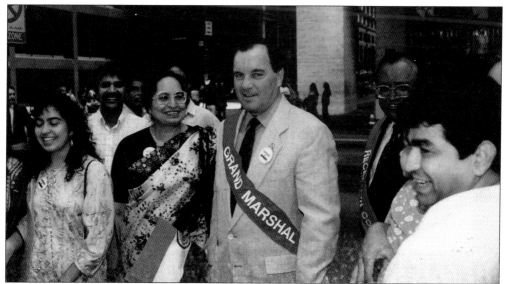

Mayor Richard M. Daley is pictured with members of Chicago's Asian-Indian community at the India Independence Day parade in 1993. The event was held on Michigan Avenue. (Courtesy Holime Collection.)

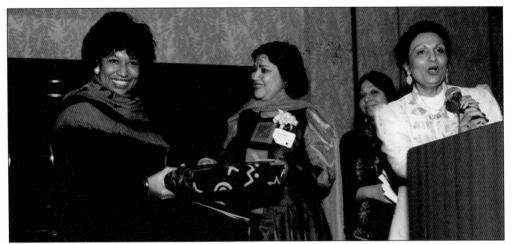

Officers of the Club of Indian Women present a gift to Illinois Democrat Senator Carol Moseley Braun at their annual dinner banquet in 1993. Braun was the first African-American woman to be elected to the U.S. Senate. (Courtesy Holime Collection.)

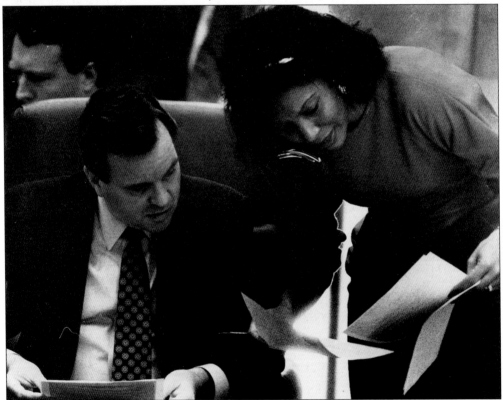

Mayor Daley confers with his press secretary, Avis LaVelle, prior to his first city council meeting. LaVelle's appointment as press spokesperson at the outset of the 1989 campaign was considered to be Daley's most adroit political move. A well-respected journalist, LaVelle was not only a first-rate press secretary, but her appointment also sent a message to independents and liberals that Daley's administration would be open to new and different types of individuals. (Courtesy Office of the Mayor.)

Four

ROLLING OUT THE RED CARPET

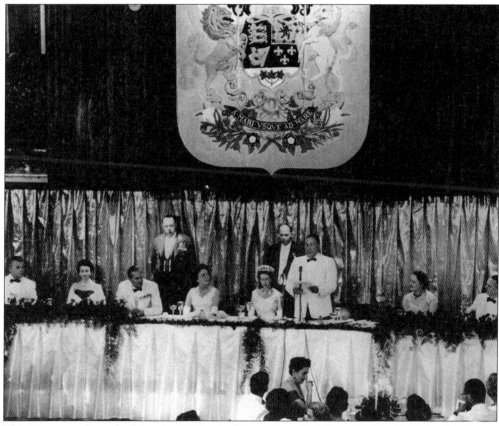

This is a scene from the historic 1959 gala dinner given by Mayor Richard J. Daley for Queen Elizabeth and Prince Phillip. The guests on the dais are, from left to right, as follows: Canadian Prime Minister John Diefenbaker and his wife; Prince Philip; Mrs. Richard J. Daley; Queen Elizabeth; Mayor Daley; and Governor and Mrs. William Stratton of Illinois. (Courtesy British Consul General's Office, Chicago.)

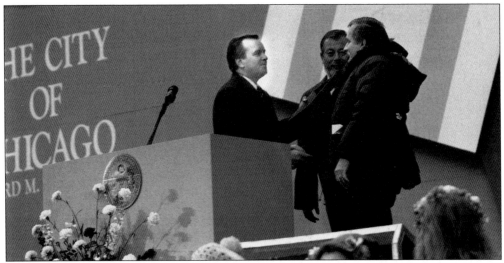

An emotional moment for Chicago's huge Polish population came when Mayor Daley welcomed Polish leader Lech Walesa to the city. Unknown to most of the enormous crowd witnessing this historic event on a typical, wintry Chicago day was the fact that Walesa was given his warm ski parka shortly before the ceremony by a very astute Daley aide. She purchased the coat quickly after seeing Walesa arrive for the event wearing only a suit coat. (Courtesy City of Chicago.)

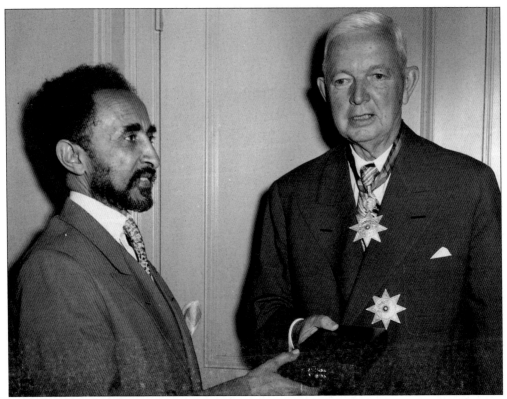

In the summer of 1954, Mayor Kennelly welcomed Ethiopian Emperor Haile Selassie to Chicago. (Courtesy Kennelly Collection.)

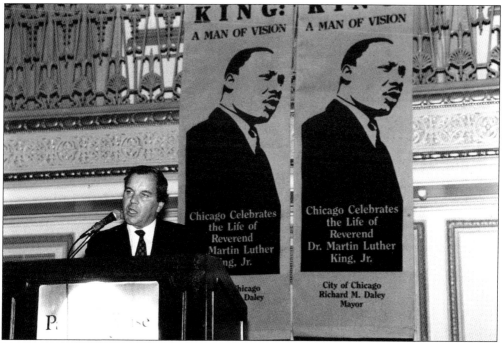

Mayor Richard M. Daley addresses the annual Martin Luther King Jr. unity breakfast. This huge event is held on the anniversary of Dr. King's birth and brings together leaders from the city's diverse racial and ethnic communities. (Courtesy City of Chicago, Press Secretary's Office.)

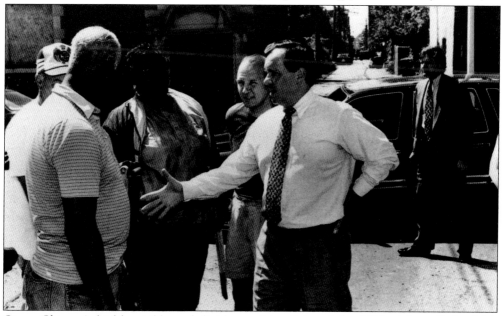

Given Chicago's highly visible and divisive racial politics of the 1980s, Mayor Richard M. Daley has worked hard to reach out to the city's African-American community. Though politically he receives the votes of only one in four black voters, Daley still maintains a strong presence in many black neighborhoods. (Courtesy City of Chicago, Graphic and Reproduction Center.)

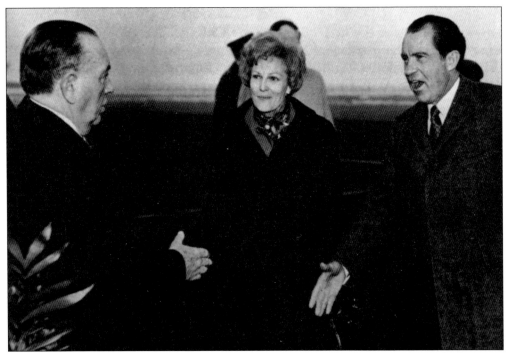

Mayor Richard J. Daley, one of the most diehard Democrats in the country, cordially greets Republican President and Mrs. Richard Nixon at O'Hare Airport. Daley had true reverence for the office of President, and it was also good politics for his city. (Courtesy Urban Historical Collection, Rakove File.)

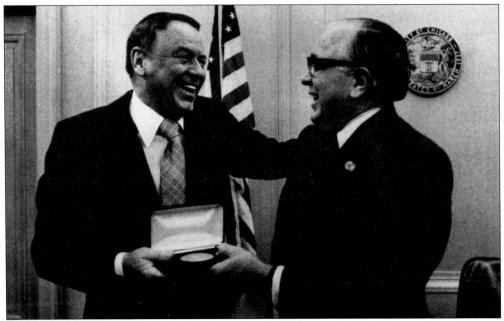

"Old Blue Eyes," Frank Sinatra receives a key to the city from Mayor Daley. The mayor was a big fan of Sinatra's vocal version of the song *Chicago—My Kind of Town*. (Courtesy Office of the Mayor's Press Secretary.)

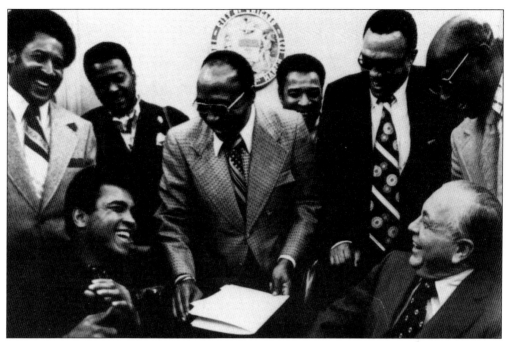
Boxer Muhammad Ali is made an honorary Chicago citizen by Mayor Daley. (Courtesy City of Chicago.)

Mayor Richard J. Daley is seated between his director of Consumer Affairs, Jane Byrne, and northside political powerhouse and Chicago Park District Superintendent Ed Kelly at a Chicago White Sox baseball game. Sitting behind the mayor is White Sox owner Bill Veeck. Daley loved to relax at a Comiskey Park, though as this picture shows, the mayor seldom unbuttoned his suit coat or loosened his tie. (Courtesy Edmund Kelly.)

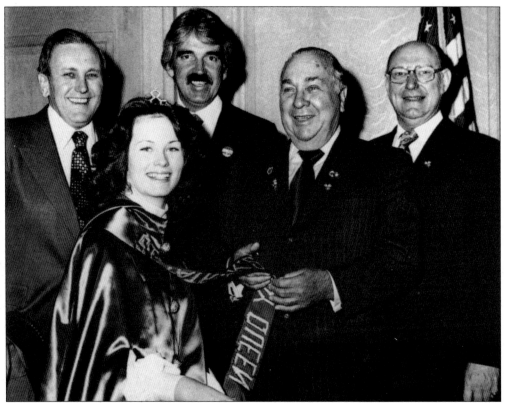
Mayor Daley congratulates 1976 St. Patrick's Day Queen Cathy O'Connell as parade chairman Ed Brabec, Irish Fellowship Club president Jim Riley, and Hilton Hotel executive Bill Smith look on. (Courtesy St. Patrick's Day Parade Committee.)

Mayor Daley's legendary sense of humor shines through as he welcomes members of the visiting Ringling Brothers Circus to his office. (Courtesy City of Chicago, Graphics and Reproduction Center.)

Beaming Chicago Mayor Jane Byrne (left) greets Queen Beatrix of the Netherlands. (Courtesy Rosalie Clark Collection.)

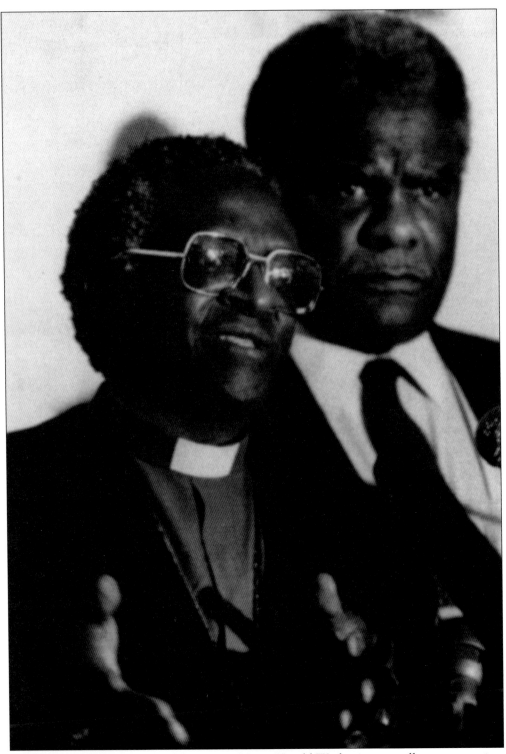
South African Bishop Desmond Tutu visits Mayor Harold Washington to rally support against South African apartheid policies. (Courtesy Office of the Mayor.)

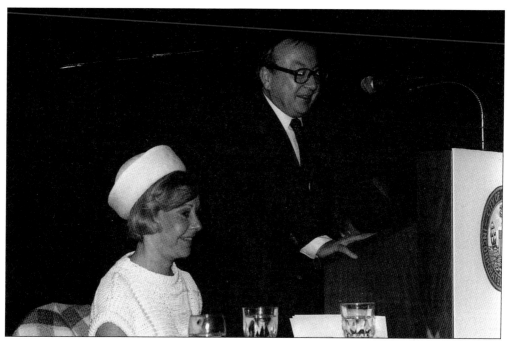

Mayor Byrne enjoys the luncheon remarks made by the Prime Minister of Turkey. (Courtesy Rosalie Clark Collection.)

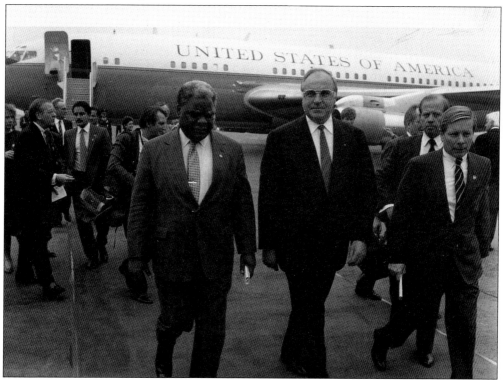

Mayor Washington greets West German Chancellor Helmut Kohl at O'Hare Airport. (Courtesy Rosalie Clark Collection.)

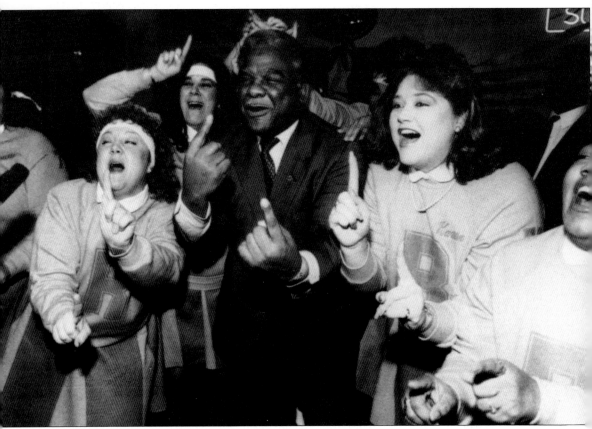
Mayor Washington celebrates the Chicago Bears' 1986 Super Bowl victory with the "Refrigerettes." These somewhat beefy cheerleaders were named in honor of the Bears' heaviest player William "The Refrigerator" Perry. (Courtesy City of Chicago.)

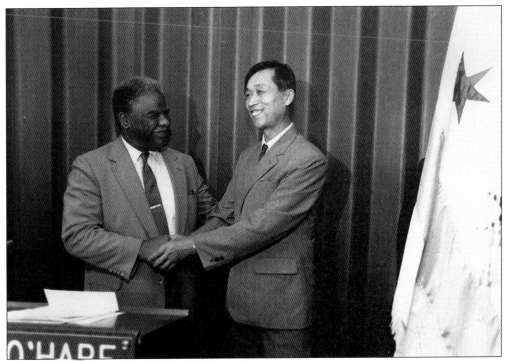

Mayor Washington is shown here welcoming Mayor Wu of Shenyang, China, which is Chicago's Sister City. (Courtesy Rosalie Clark Collection.)

Mayor Eugene Sawyer hosted a reception for the Princess of Thailand (right). Also seen in the picture is Rosalie Clark, the director of protocol for the City of Chicago. (Courtesy Rosalie Clark Collection.)

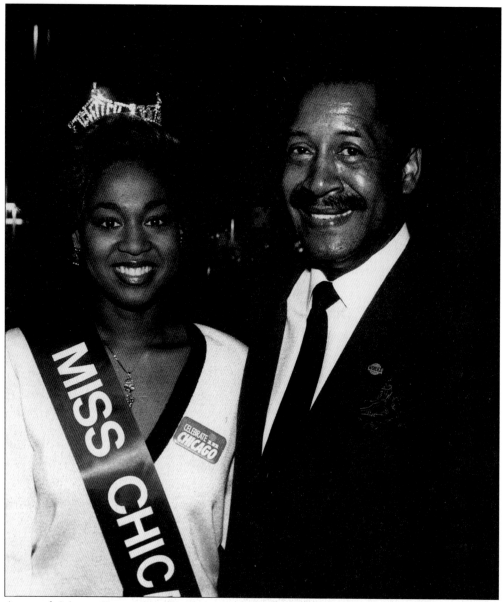
A proud Mayor Sawyer stands next to Miss Chicago in this view. (Courtesy Holime Collection.)

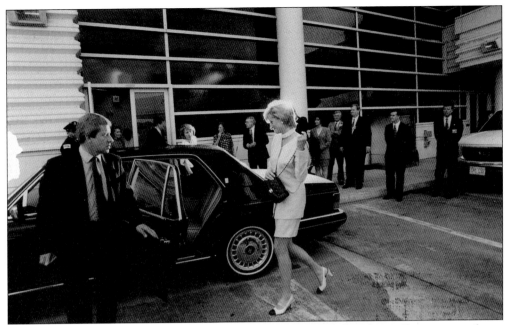

In 1996, Princess Diana literally turned Chicago into a British colony. She captivated one and all in a series of meetings, luncheons, and dinners. Here she is seen arriving in Chicago at O'Hare Airport. (Courtesy Rosalie Clark Collection.)

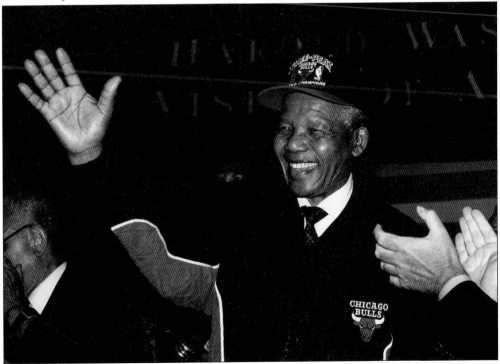

South African President Nelson Mandela was given a huge citywide reception as well as a Chicago Bulls jacket and hat during his brief visit to the city. (Courtesy Rosalie Clark Collection.)

Mayor Richard Daley introduces President Mandela to Chicago Police Superintendent Matt Rodriquez. Standing beside Mandela is the Reverend Jesse Jackson. Also seen in this picture is Jim "Skinny" Sheahan, who, as director of the Mayor's Office of Special Events, played a major role in orchestrating all the activities of visiting dignitaries. (Courtesy Rosalie Clark Collection.)

Mayor and Mrs. Richard M. Daley greet the King and Queen of Norway at Chicago's newly remodeled Navy Pier. (Courtesy Rosalie Clark Collection.)

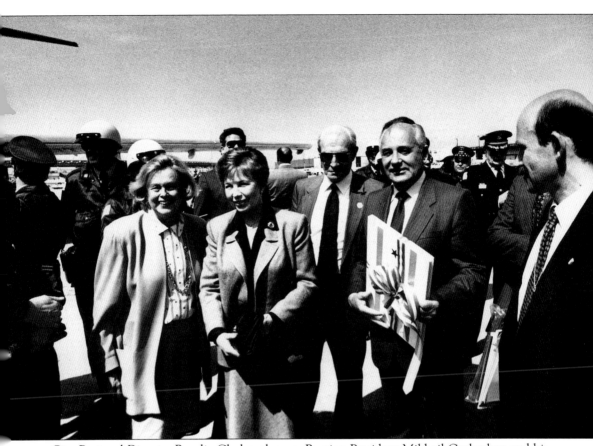
City Protocol Director Rosalie Clark welcomes Russian President Mikhail Gorbachev and his wife, Raisa (center), to Chicago. (Courtesy Rosalie Clark Collection.)

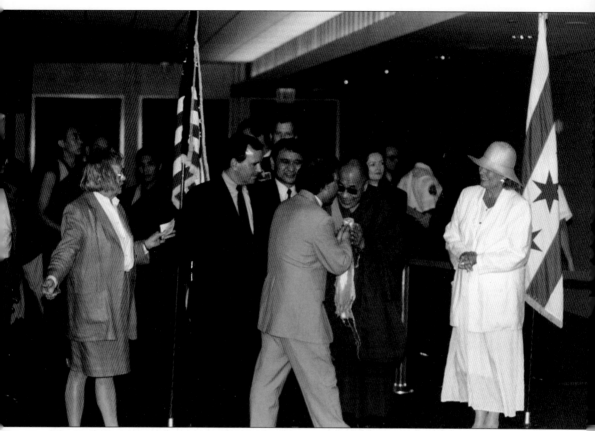
The Dalai Lama is pictured at a City Hall reception outside the mayor's fifth-floor office. Mayor Daley and his wife Maggie look on intently as their guest meets his admirers. (Courtesy Rosalie Clark Collection.)

Five
DALEY TO DALEY

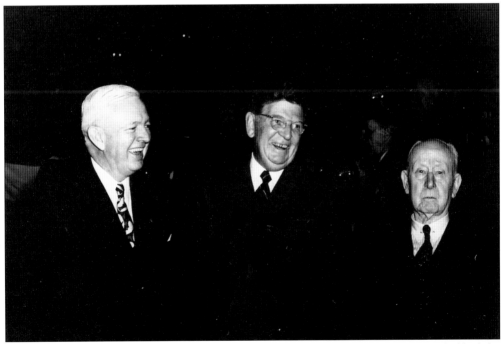

These three former Chicago mayors, who led the city through much of the first half of the 20th century as well as a part of the 19th century, are pictured here, along with the dates of their terms in office. They are, from left to right, as follows: Martin Kennelly (1947–1955), Ed Kelly (1933–1947), and Carter H. Harrison II (1897–1905 and 1911–1915). (Courtesy M. Kennelly Papers.)

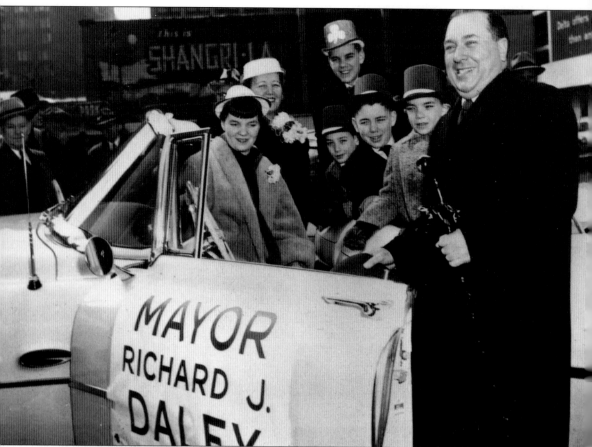
In 1956, Mayor Richard J. Daley decided to walk instead of ride in his first St. Patrick's Day parade. About to send him off with his walking stick is his wife and family, including a future Chicago mayor, young Richard M. He is seen in the background wearing the tall hat with the shamrock. (Courtesy Urban Historical Collection.)

Richard J. Daley loved to lead the city's St. Patrick's Day parade. He is shown here marching in the 1974 parade, flanked on his right by movie stars Chuck Conners and Forrest Tucker. On his left are political and civic leaders Ed Brabec (parade chairman), Police Superintendent James Rochford, and Lt. Gov. Neil Hartigan. Parades have played a huge role in Chicago's overall political scene and have been an accurate barometer of political leadership and changing city demographics. (Courtesy Holime Collection.)

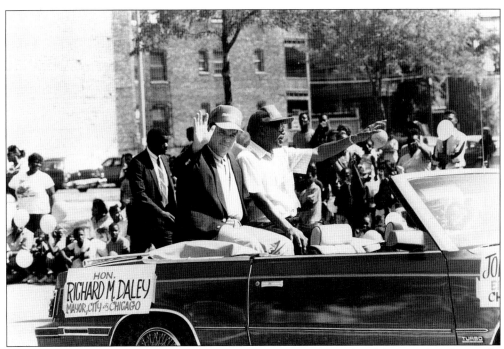

New Chicago Mayor Richard M. Daley is shown riding in the Bud Billikin South Side parade. This parade, sponsored and created by the city's leading Black newspaper, the *Chicago Defender*, is an important annual event in the city's African-American community. (Courtesy City of Chicago, Press Secretary's Office.)

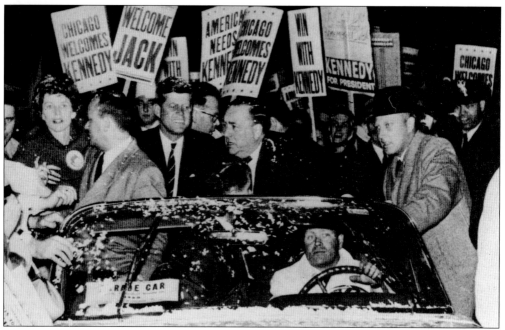

Five days before the 1960 presidential election, Chicago Mayor Richard J. Daley orchestrated the largest torchlight political parade in the city's history for Sen. John F. Kennedy. As chairman of the Cook County Democratic organization, Mayor Daley went all out, organizing a large number of his party workers as well as average citizens who lined Madison Street for the Democratic presidential candidate. (Courtesy Kennedy for President Campaign.)

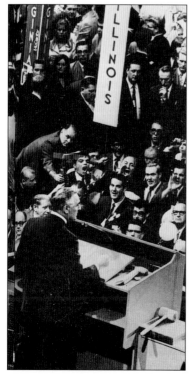

This was an unhappy time for Mayor Richard J. Daley, seen here shouting "faker!" to Connecticut Sen. Abraham Ribicoff at the tumultuous 1968 Democratic National Convention in Chicago. During his nomination of George McGovern for U.S. President, Ribicoff verbally attacked Daley and the city's police department for its handling of demonstrators outside the Conrad Hilton hotel in downtown Chicago. (Courtesy *Chicago Sun-Times.*)

Chicago Tribune
THE WORLD'S GREATEST NEWSPAPER

Saturday, July 1, 1972

Mayor Assails Action

Daley Delegates Dumped

Anti-Daley members of the Credentials Committee cheer after the mayor's delegation was unseated. Louise Hutchinson reports "It was like one of the Irish celebrations they used to hold on Chicago's South Side."
(Story on page 2)

BY PHILIP WARDEN
(Chicago Tribune Press Service)

WASHINGTON, June 30 — Forces for Sen. George McGovern [S. D.] succeeded tonight in getting the Democratic Convention Credentials Committee to oust Mayor Daley and his 58 Cook County delegates.

The committee voted to replace Daley's delegation with a group headed by Chicago Ald. William Singer [43d], 41 of whom support McGovern. The Daley delegates were uncommitted.

Vote Is Changed

The vote was originally 71 to 61, with seven abstentions. But the chair ruled the abstentions should be counted as votes for Daley, which meant that the Chicago mayor lost by only three votes.

It was a bad day for regular Democratic organizations in Illinois. This morning, the committee voted, 70 to 65, to add 24 delegates to four Downstate congressional districts to give women, blacks, and young people better representation. McGovern gained eight delegates.

The committee also voted, 76 to 63 to cancel the credentials of Dr. Andrew Toman, Cook County coroner; and Township Commissioner James Kirkie, and to replace them with women.

Ald. Claude Holman addresses Credentials Committee.

affirmed the principles that we have been urging upon the Democratic Party and the other 49 states. The Democratic Party leadership has taken an aggressive role in implementing reform guidelines.

"In Chicago they were ignored, and the vote of the Credentials Committee reflected the belief of most of the members.

[Continued on page 2, col. 1]

Nixon Gets Bill to Hike Benefits 20%

BY ARTHUR SIDDON
(Chicago Tribune Press Service)

WASHINGTON, June 30 — Congress tonight approved a 20 per cent increase in Social Security benefits and attached it to an unrelated bill President Nixon urgently wanted.

The benefit increase was a rider on a bill sent to Nixon extending the $450 billion debt ceiling.

The Social Security hike, which the President warned he may veto, would make available $8.5 billion a year in additional payments effective

Sept. 1 to 27.8 million, out of eight Americans.

In his press conference day night, Nixon said per cent boost might p flationary or would hu payers. He said the boos "completely wipe out" ductions given lower and income persons three yea

Despite administratio pleasure, the Social Secu crease was tacked on debt ceiling bill in the

[Continued on page 6,

Will Keep Fighting: Daley

Mayor Daley said last night Earlier in the day Illinois State Chairman Victor L. Smith tials Committee today is re

Legislature OKs Budget

This unbelievable 1972 *Chicago Tribune* headline revealed that the Democratic Convention Credentials Committee had, by a narrow margin, voted against seating 58 duly elected Illinois convention delegates allied with Mayor Daley. A few weeks later, delegates at the national convention in Miami Beach, Florida, would reaffirm this decision in a heated floor battle. (Courtesy Holime Collection.)

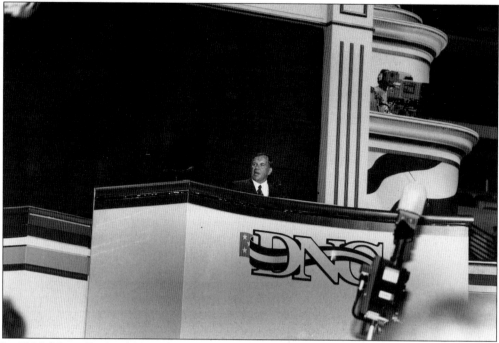

In 1996, Mayor Richard M. Daley exorcised the National Party Convention demons that had plagued his father in 1968 and 1972. Chicago and the mayor received rave reviews for running the Democratic Party's 1996 National Convention in a fair and efficient manner. These two photos show Mayor Daley addressing the convention and receiving thunderous applause. (Courtesy City of Chicago, Press Secretary's Office.)

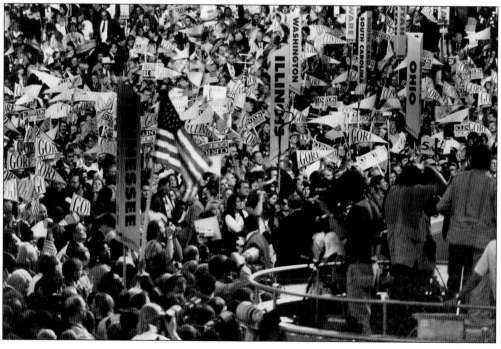

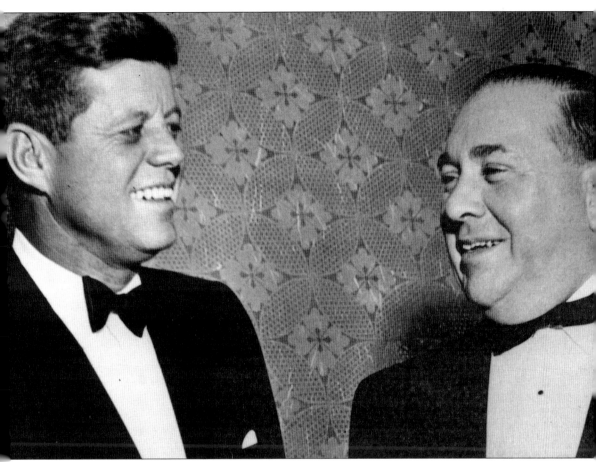

The Daleys and the Kennedys have had a close relationship that can be traced back to the 1950s, when Joseph P. Kennedy Sr. and Richard J. Daley became political allies. The elder Kennedy had become a Chicago player when he purchased the Merchandise Mart—a huge office and commercial structure—in 1946. This picture shows Pres. John Kennedy and the mayor truly enjoying each other's company. (Courtesy City of Chicago.)

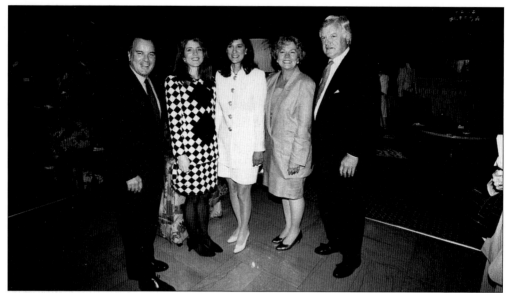

Mayor Richard M. Daley and his wife Maggie (second from the right) are pictured at a civic function with Caroline Kennedy, Mrs. Edward Kennedy, and Massachusetts Sen. Edward Kennedy. The Kennedy-Daley alliance has held firm, except for the period when Jane Byrne was Chicago's mayor. In the classic and brutal three-way 1983 Chicago Mayoral Democratic primary, Kennedy endorsed Byrne over Daley and Harold Washington. (Courtesy City of Chicago, Press Secretary's Office.)

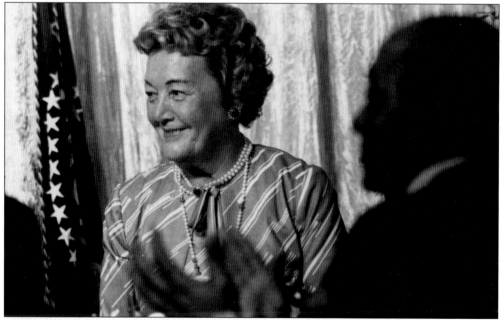

This rare photo is a recent view of of Eleanor "Sis" Daley at a downtown dinner. Mrs. Daley, the wife to Richard J. and mother of Richard M., is a kind beloved "Queen Mum" to many Chicagoans. She is one of the few remaining links between the two Daley eras. She conducted herself with incredible dignity and grace in the decades following her husband's death. (Courtesy City of Chicago, Graphics and Reproduction Office.)

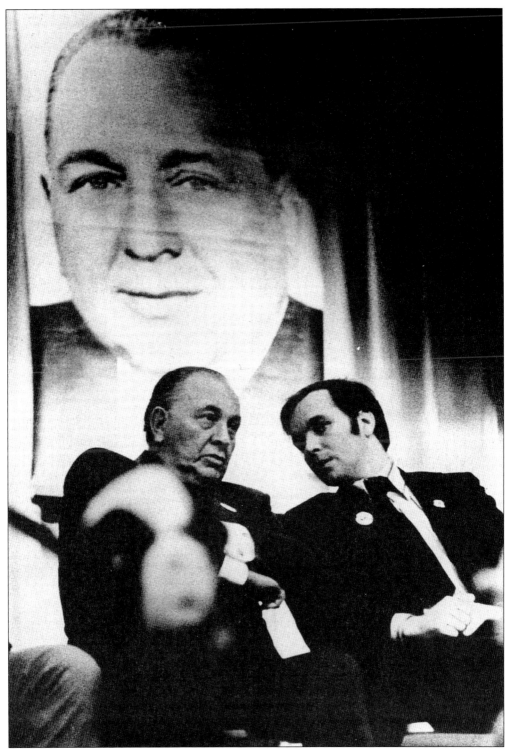
This photo was taken during Richard J. Daley's last campaign for mayor in 1975. Old pro Daley took great pride in his son's career as an Illinois state senator. (Courtesy Office of the Mayor.)

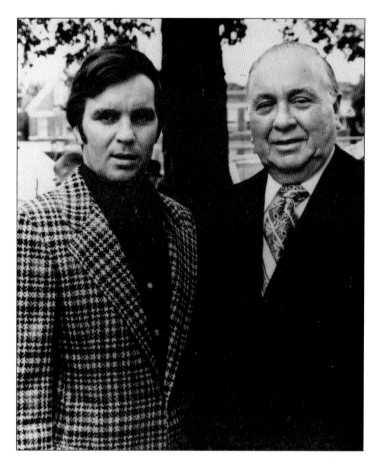

The son, who has served in office since 1989, and the father, who served from 1955 to 1976, have together led Chicago for three of the five decades since 1950. Alike in many ways and different in others, both men have shared one overriding belief: Chicago is not only their kind of town, it's also the greatest city in the world. (Courtesy City of Chicago, Press Secretary's Office.)

20th-Century Chicago Mayors

1901–1905	Carter Harrison–D
1905–1907	Edward Dunne–D
1907–1911	Fred Busse–R
1911–1915	Carter Harrison–D
1915–1923	William Hale Thompson–R
1923–1927	William Dever–D
1927–1931	William Hale Thompson–R
1931–1933	Anton Cermak–D
1933–1933	Frank Corr–D
1933–1947	Edward Kelly–D
1947–1955	Martin Kennelly–D
1955–1976	Richard J. Daley–D
1976–1979	Michael Bilandic–D
1979–1983	Jane Byrne–D
1983–1987	Harold Washington–D
1987–1989	Eugene Sawyer–D
1989–Present	Richard M. Daley–D